FREDERIC REMINGTON

173 DRAWINGS AND ILLUSTRATIONS

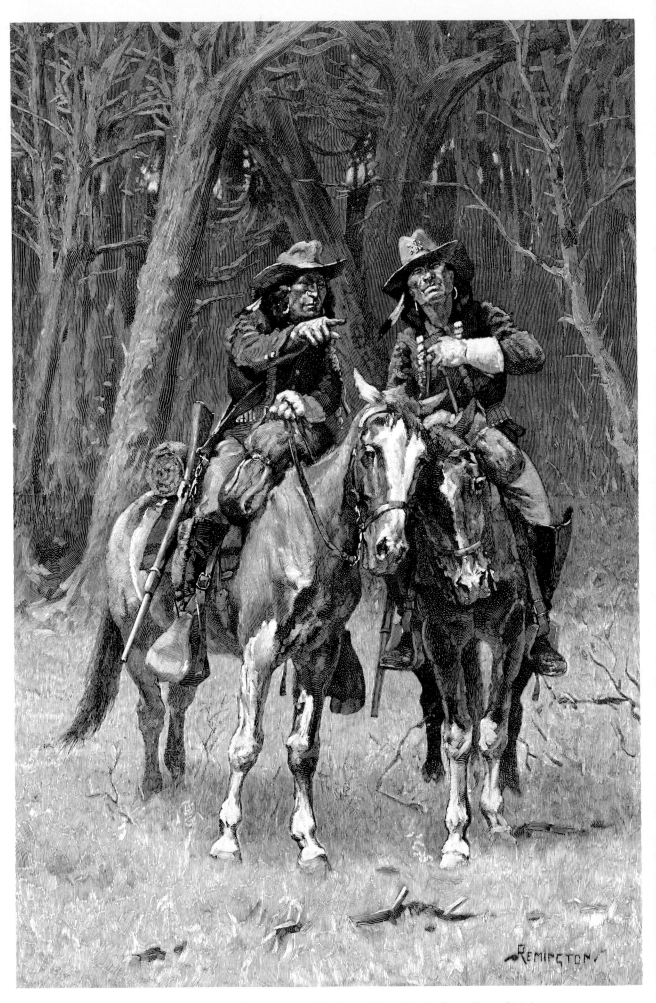

Cheyenne Scouts Patrolling the Big Timber of the North Canadian, Oklahoma

FREDERIC REMINGTON

173 DRAWINGS AND ILLUSTRATIONS

SELECTED AND WITH AN INTRODUCTION BY

HENRY C. PITZ

author of *The Brandywine Tradition; Pen, Brush and Ink;*
The Practice of Illustration; etc.

DOVER PUBLICATIONS, INC., NEW YORK

Published in Canada by General Publishing Company, Ltd., 30 Lesmill Road, Don Mills, Toronto, Ontario.

Published in the United Kingdom by Constable and Company, Ltd., 10 Orange Street, London WC 2.

Frederic Remington: 173 Drawings and Illustrations is a new selection of drawings first published by Dover Publications, Inc., in 1972. The introduction was written specially for this volume by Henry C. Pitz.

The illustrations were reproduced from the following sources:

(1) *Drawings by Frederic Remington,* published by R. H. Russell, New York, 1897 (all 61 drawings from this book are included in the present volume).

(2) *The Oregon Trail: Sketches of Prairie and Rocky-Mountain Life,* by Francis Parkman, illustrated by Frederic Remington, published by Little, Brown, and Company, Boston, 1900.

(3) *Ranch Life and the Hunting-Trail,* by Theodore Roosevelt, illustrated by Frederic Remington, published by The Century Co., New York, 1902.

(4) *The Book of the American Indian,* written by Hamlin Garland, pictured by Frederic Remington, published by Harper & Brothers, New York, 1923.

(5) Various issues of *Harper's Weekly* between 1886 and 1895 (exact dates in List of Plates).

International Standard Book Number: 0-486-20714-5
Library of Congress Catalog Card Number: 78-158963

Manufactured in the United States of America
Dover Publications, Inc.
180 Varick Street
New York, N.Y. 10014

INTRODUCTION

As the West of the frontier recedes from us, its power as myth grows. It is fast in the American imagination and that of the entire world. There, it shapes its travesties and glorifications. The cool, fact-finding social historians have diligently searched out the apparent realities, but to most of us the frontier West is a land that never was—we have remade it to our purpose.

We have fed upon the written word, largely fiction, and the picture, which has become increasingly fictional. The motion picture and television have implanted persistent images in our minds—images which do not always entirely satisfy and which, more and more, we tend to question. There is an increasing yearning to reach back to our sources, to cast off the adulterations, subject the boring stereotypes to the cleansing of ridicule and balance the truth of what actually happened with the wonder and invention that tease our minds into fable-making.

Our picture-makers have been diligent enough and talented enough to supply both abundant facts and ample pictorial drama to ignite our imaginations. Almost all were afire with great expectations before they ever faced the real scene. The West left its stamp on every one of them, often leading to a lifelong commitment. They constitute an accomplished company of the most diverse abilities, backgrounds and outlooks and the enormous gallery of their work is largely available to us in public collections and in reproduction. From the early Samuel Seymour, Peter Rindisbacher and James Otto Lewis to the far more accomplished George Catlin and John Mix Stanley, the Swiss-born Karl Bodmer and Friedrich Kurz, the grandiloquent Albert Bierstadt and the Brothers Moran, and the men of the last decade of the frontier, notably Charles Schreyvogel, Charles M. Russell and Frederic Remington, the pictorial record has been furnished by many varied temperaments. Their reports have been far from identical, but wonder and drama are there in even the least accomplished. Each artist records the shock of new experiences, sights never seen before.

Yet only the specialist knows more than a meager handful of these names. If there is a public image of the old West it is strongly conditioned by the work of one artist, Frederic Remington. His pictures have had a much wider circulation than others, his work has strongly influenced the picture-making of several generations of later painters and illustrators of Western subjects (artists who arrived too late to have first-hand experience), and the motion picture directors have plundered his work for costumes and types. No other artist has left us such wide-ranging documentation of the old West. There was nothing of the detached observer about him—he convinces us that what he painted was part of his blood and bones.

Remington came upon the scene at the opportune time. The frontier was in its last phase. He came in time to see the last pathetic belligerence of the Indian, the wide ranges being nibbled at by barbed wire and the homesteader, the railway towns springing up overnight, the gold rushes and the last of the great buffalo herds. He intuitively comprehended what was happening and devoted his life to recording it.

Like practically all the depictors of the frontier, he was not born in that westward-creeping belt. He felt its call in his boyhood years and first saw it with the hungry eyes of early manhood. His birthplace in 1861 was the small town of Canton in northern New York, not far from the St. Lawrence River. His father, Seth Remington, was a newspaper owner and editor, but the Civil War was on, and he left his two-month-old son to raise a squadron of cavalry in what became the well-known Eleventh New York Cavalry. Four years later, a battle-tried veteran and a lieutenant colonel, he returned to Canton to the newspaper business and the opportunity to become acquainted with his strong, impetuous, four-year-old son.

The youngster's growing years were a fairly usual story of indifference to lessons, of school-books scrawled with childish versions of Indians, soldiers and horses. He was a sturdy, active boy, a swimmer, a rider, a fisher and a leader in all sports. When he reached his teens he was sent to a military school, for his soldier father felt he needed discipline. But the strict regulations of the new school aroused immediate rebellion and the thirteen-year-old ran away. Brought back and punished, he finally submitted to the school routine and gradually became a well-liked if not outstanding student. His passions were still drawing and sports. His fingers itched for the pencil and his strong muscles craved movement. At about the age of sixteen he described himself thus: "My hair is short and stiff and I am about five feet eight inches and weigh one hundred and eighty pounds. There is nothing poetical about me."

At seventeen he entered Yale. His scholastic record continued to be unremarkable. An art class had just been opened and he found himself one of a class of two. He was put to making

Page from a sketchbook Remington used at military school as a youth. (Courtesy of the Remington Art Memorial, Ogdensburg, N.Y.)

meticulous drawings from plaster casts of classical and Renaissance sculpture—the academic routine of the time. Again rebellion was aroused and he conceived a lifelong dislike for academic art education. His solace during less than two years at Yale was the indulgence in spare-time sketching and playing varsity football. It was beginning to be obvious that he was not going to fit into any of the conventional business or professional grooves that his mother hoped for.

The death of his father in 1880 brought his college days to an end. He resisted his mother's urge to complete his education; he now had a small inheritance that made him feel independent and he was eager to taste the outside world. He took a political job offered him and speedily became bored. He fell in love and when told by the girl's father that he had shown no signs of the stability necessary to earn a living and raise a family, he determined to go West, where sudden fortunes were made, and to return in due course to confront the stubborn man.

The West was all that he had dreamed of and more. The nineteen-year-old youth was immediately at one with the land, the people, the climate, the animals. He was a natural horseman and in a short time had mastered the lariat. With a tough, untiring body went boundless curiosity and an artist's eye. He was a good shot and could use his fists. He found himself at home with cowhand, trapper, homesteader, Indian or prospector. He could drink with the best or worst. The West he found to be his natural home.

His restless curiosity carried him over large parts of the West, into many hidden and remote areas. There was an interval as a hired cowhand and another with a wagon train through the Rockies. The Indians fascinated him and he spent much time in their encampments, teaching himself their tribal differences and drawing them. He traveled over the Santa Fe Trail, the Oregon Trail of the homesteaders and the cattle trails from the deep ranges to the shipping points. Then he rode north to the Canadian border and south to cross into Mexico. He listened to the oldtimers and asked questions of everyone. Western lore was filling him to the brim.

There was still indecision in his mind. His pencil was busy recording the new life and he

Action sketches from one of Remington's late sketchbooks. (Courtesy of the Remington Art Memorial, Ogdensburg, N.Y.)

experienced the first sign of encouragement for his picture-making. A sketch on wrapping paper was mailed to *Harper's Weekly* and, crude though it was, it was accepted, redrawn by a professional and printed in the issue of February 25, 1882. The caption read, "Cow-boys of Arizona: Roused by a Scout," and the byline said, "Drawn by W. A. Rogers from a Sketch by Frederic Remington." It was no small feat to be published at twenty-one in one of the most important magazines of the day, even if the picture had to be redrawn by a more experienced artist.

But there was still the hankering to grab a quick fortune and return in triumph to the girl he wished to marry, so he impulsively bought a small ranch near Kansas City and began raising mules. Disillusionment came soon enough. Impatient, he sold out and with diminished capital set out on a sketching expedition into the Indian territory.

This time he was ready to make a great effort to live by his picture-making. He bought a small house in Kansas City and began working up his sketches. Presently he was making sales and confidence in his talent was growing. But the persistent urge to make quick money led him into a disastrous business partnership and most of his remaining capital vanished. Almost penniless, he made his way back to New York State to see his mother and his sweetheart, Eva Caten. To his surprise, Mr. Caten withdrew his opposition and the two young people were married quietly in the Caten house.

The young couple went back to the little house in Kansas City and Frederic struggled to support two on his meager sales of pictures. It was a losing struggle. Kansas City was a tough, raw town. Their families back in New York pleaded with them to return East. Finally it was decided that Eva would return and Frederic attempt again to find a livelihood somewhere in his beloved West.

It was to be gold this time. He joined several prospectors and they headed through Arizona into the wild Apache country. His search and wanderings led him back through Texas and Indian territory, and less than a year after his marriage he was back in Kansas City, penniless but with a bulging portfolio of sketches and drawings. His last hope was to get to New York

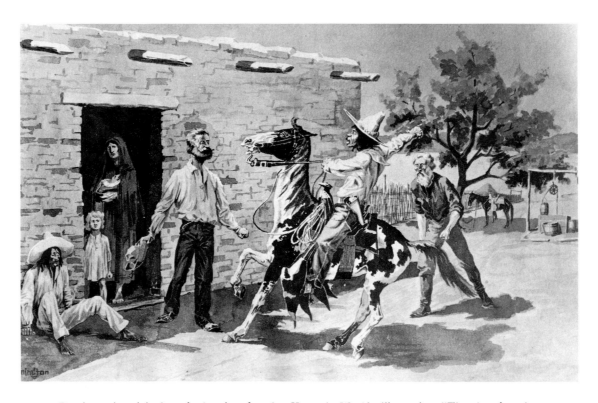

Remington's original wash drawing for the *Harper's Weekly* illustration "The Apaches Are Coming," published January 30, 1886, and reproduced as Plate 79 of this volume. (Courtesy of the Remington Art Memorial, Ogdensburg, N.Y.)

City and try to market his pictures. He arrived in the great city with three dollars in his pocket. Eva joined him and they lived with friends in Brooklyn. An uncle loaned him some money and he enrolled in the classes of the Art Students League in an effort to perfect his drawing. Probably some improvement came from his brief sessions at the League, but essentially he was a loner who had to work things out for himself. However, his new League acquaintances, such as Arthur B. Frost and E. W. Kemble, gave him the stimulus of other friendly talents fighting the same battle toward professionalism.

Then the tide began to turn. He sold a picture to *Harper's Weekly* and this one appeared under his name alone in the January 9, 1886 issue. *St. Nicholas,* the children's magazine, gave him a story to illustrate and Poultney Bigelow, a former Yale classmate and editor of *Outing* magazine, gave him a bundle of manuscripts to picture. From the time these pictures appeared, Remington had a growing public and was a sought-after artist.

Both magazine and book commissions came flooding in. His paintings were exhibited in the American Water Color Society and National Academy of Design exhibitions and began to win prizes. The days of poverty were over. The Remingtons moved into comfortable quarters in Manhattan and for the first time the artist had an adequate studio hung with his collection of Indian and cowboy artifacts. Now, with enough capital in the bank, he took off for the West again with a magazine assignment in the summer of 1888. He rode with a scouting party of the Tenth United States Cavalry searching for scattered bands of Apaches hiding in the hot canyons of Arizona. This time he was both writer and artist and his articles appeared a few months later in *Harper's Weekly* and *Century*.

He now had twenty-two years of acclaim, steady commissions and productive creative work ahead of him. The rapid advances in mass color reproduction gave him an opportunity to display his gifts for color. He largely abandoned pen and ink and wash for oil paint. *Collier's Weekly* gave him page after page of full color and his paintings were reproduced as portfolio and

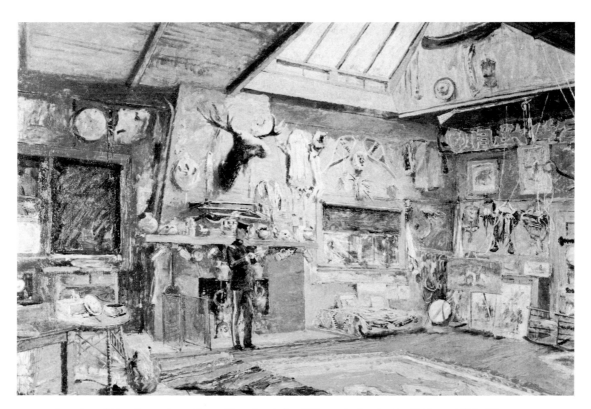

Interior of Remington's studio at New Rochelle, N.Y.; painting by Lyell Carr, 1900. (Courtesy of the Remington Art Memorial, Ogdensburg, N.Y.)

framing prints. Then, after some lessons from a sculptor friend, he began to model in clay and wax and have his figures cast in bronze. His hours in the studio were long, his energy seemed boundless and his creative powers were at a peak to within a few days of his last, short illness and death on December 26, 1909.

We inherit his monumental record of one of history's most flamboyant and significant eras. The era is there in its glory and disgrace, with its tough, greedy masculine cast performing its predestined role against a series of nature's magnificent settings. His nature demanded accuracy and abhorred the faked and the sham but his ardent eyes recognized drama and romance as ingredients of essential truth. The pedantic idea that history was a collection of cold facts was anathema to him.

He painted boldly, knowingly and with complete absorption, refusing to glamorize falsely or distort. But he knew he was dealing with epic material and felt the innate drama of it. How roundly he would have cursed the ridiculous trappings of some later artists and the motion picture studios!

Remington is a source. Not only do the social historians find him an encyclopedia of Western lore, but his traces are to be found in the works of the writers, dramatists and picture-makers who have dealt with his materials. Only the establishment critics have been cold to his powers. Together with three of his friends and contemporaries, Charles Dana Gibson, Arthur B. Frost and Howard Pyle, he helped amass a great pictorial collection of the American story. These four remarkable talents explored four aspects of American life; all four were authentically American, owing little to European influences. Reading their reports, one is immersed in the nation's historical stream.

Remington's stature is increasing with the perspective of time. His work is indispensable for our understanding of our past. But it is not history alone—it is art.

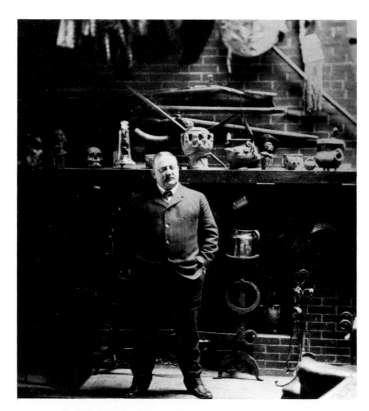

Remington in front of the fireplace in his New Rochelle studio. (Courtesy of the Remington Art Memorial, Ogdensburg, N.Y.)

LIST OF PLATES

Illustrations for THE OREGON TRAIL by Francis Parkman, 1900

Illustrations for RANCH LIFE AND THE HUNTING-TRAIL by Theodore Roosevelt, 1902

Illustrations used in THE BOOK OF THE AMERICAN INDIAN by Hamlin Garland, 1923

Drawings published in HARPER'S WEEKLY

Cover Illustrations in Full Color

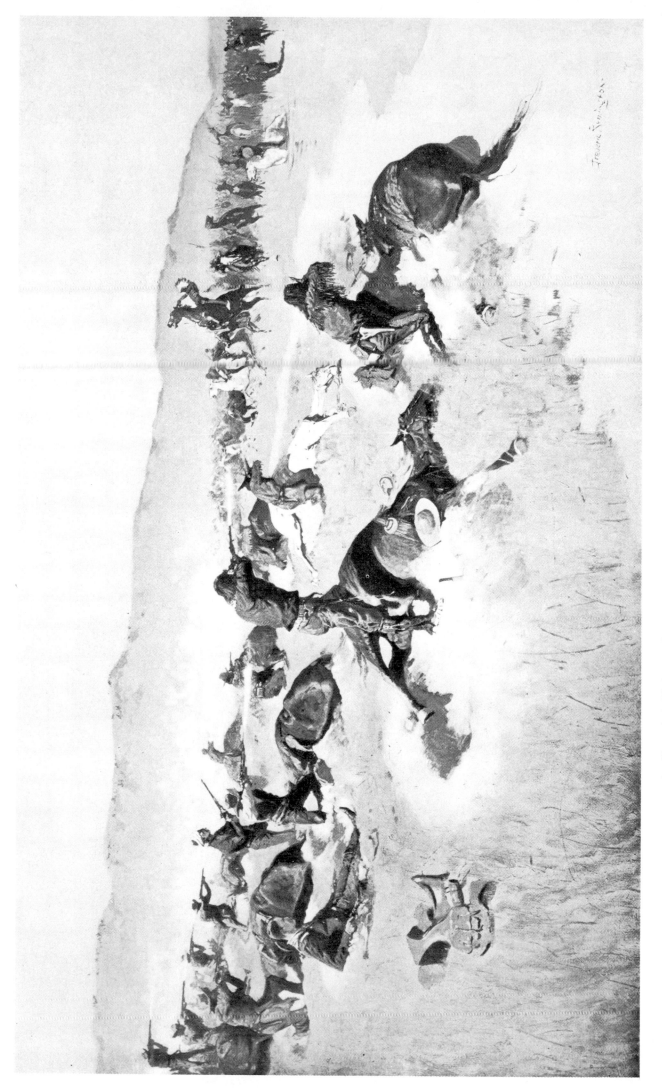

1 Forsythe's Fight on the Republican River, 1868—The Charge of Roman Nose

2 Coronado's March—Colorado

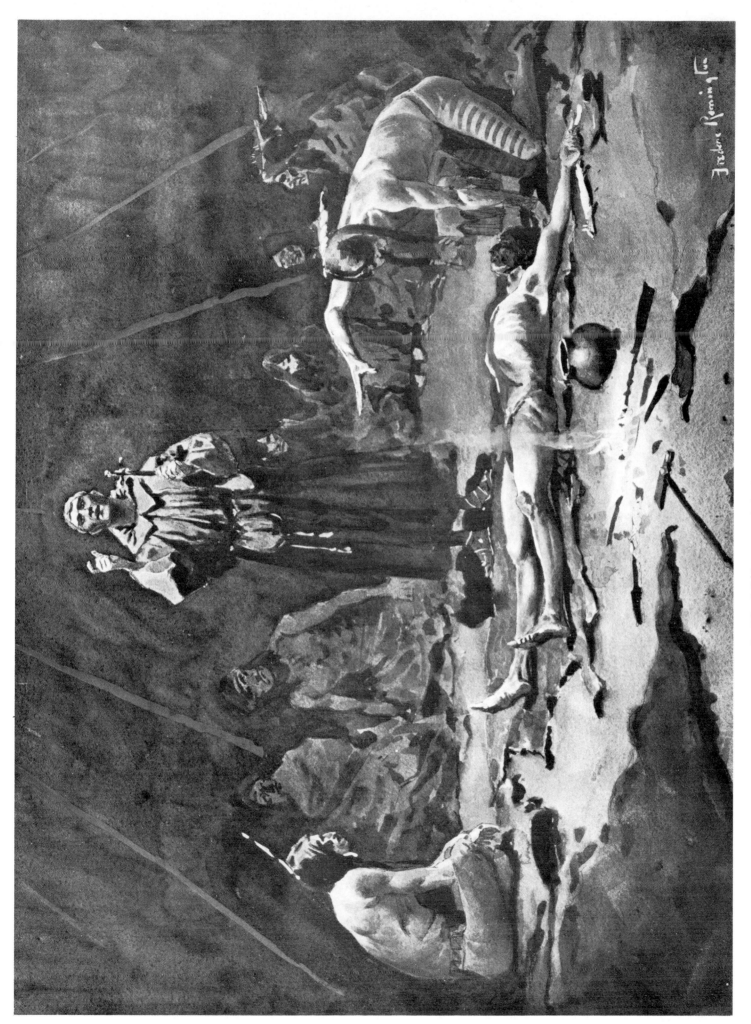

3 The Missionary and the Medicine Man

4 Hunting a Beaver Stream—1840

5 The Hungry Winter

6 Fight over a Water Hole

7 When His Heart Is Bad

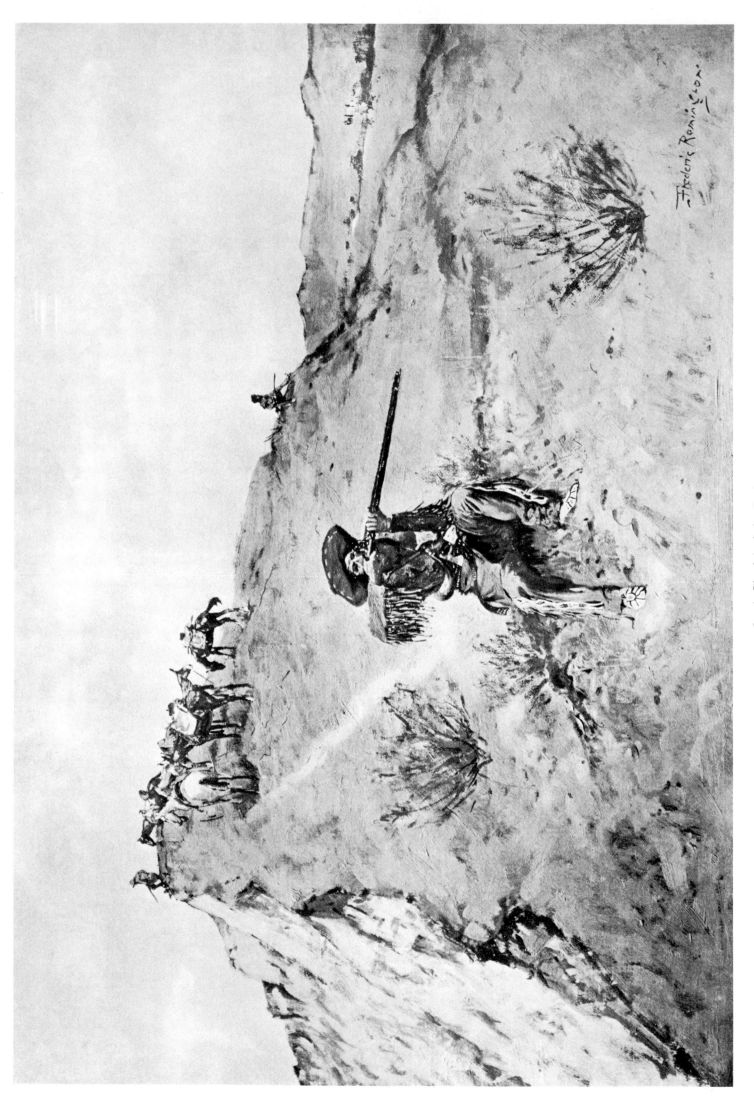

8 A Citadel of the Plains

9　On the Northwest Coast

10 The Sheep Herder's Breakfast

11 The Gold Bug

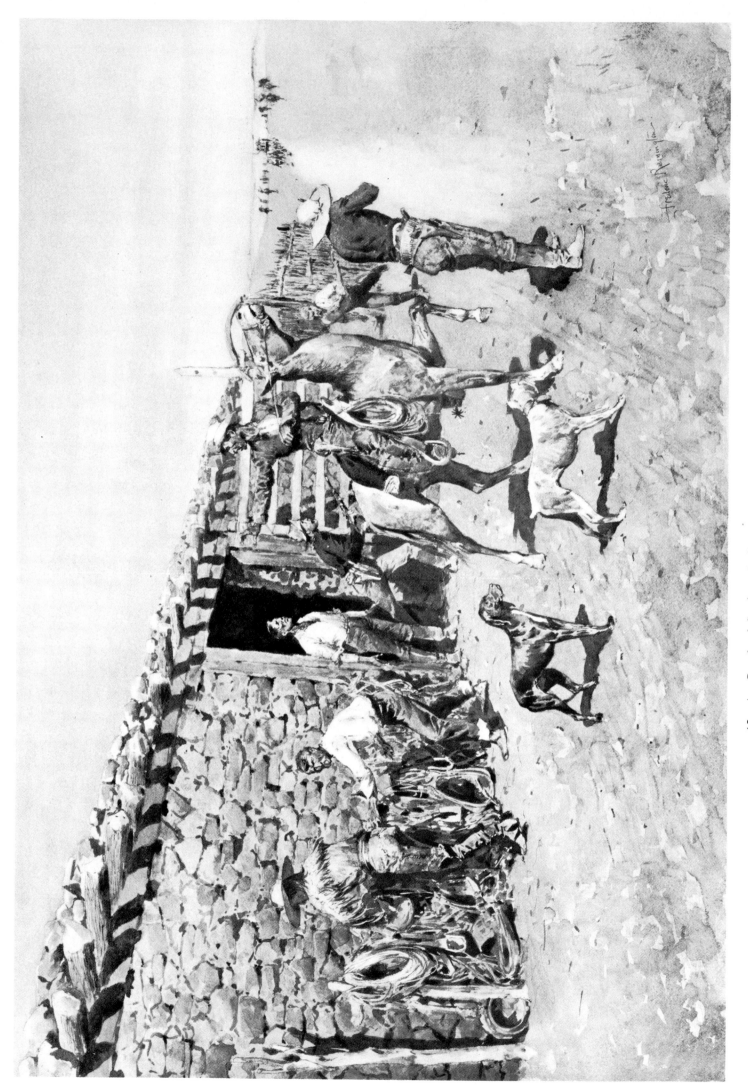

12 An Overland Station: Indians Coming in with the Stage

13 The Well in the Desert

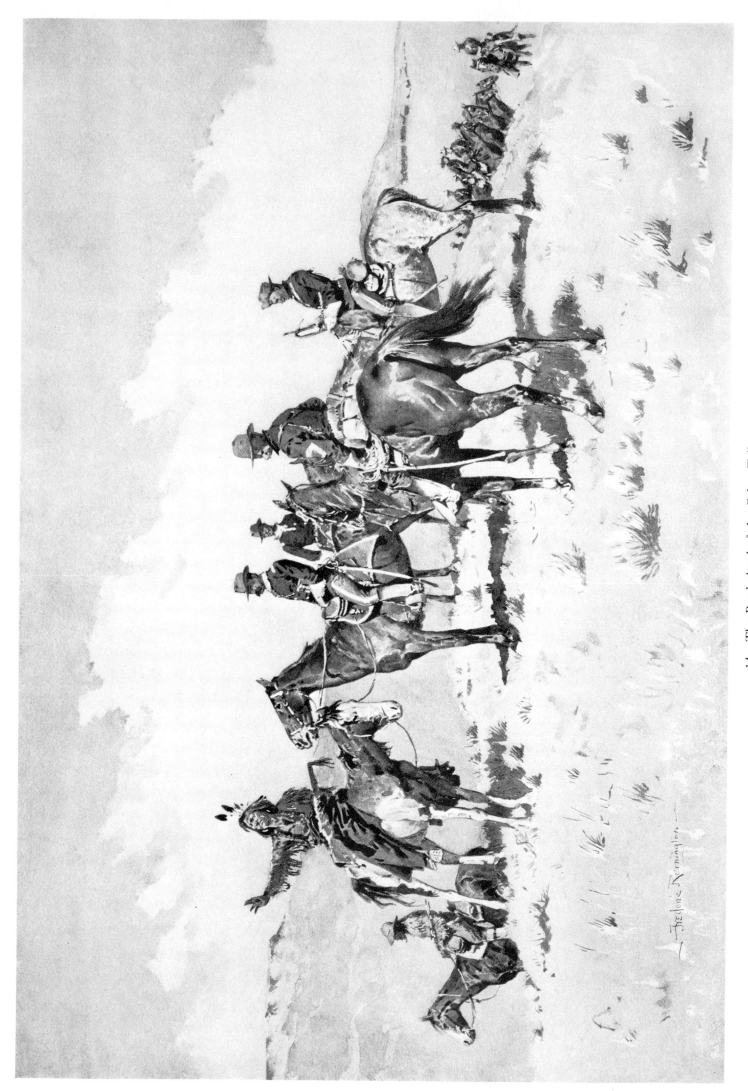

14 The Borderland of the Other Tribe

15 Her Calf

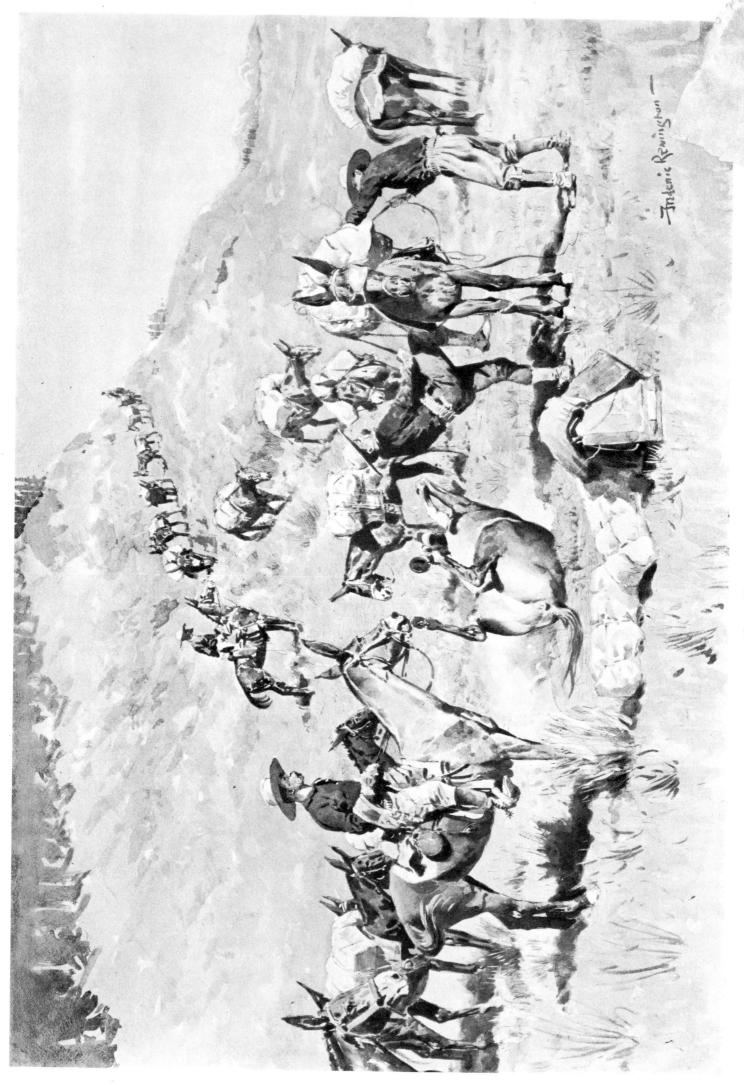

16　A Government Pack Train

17 The Charge

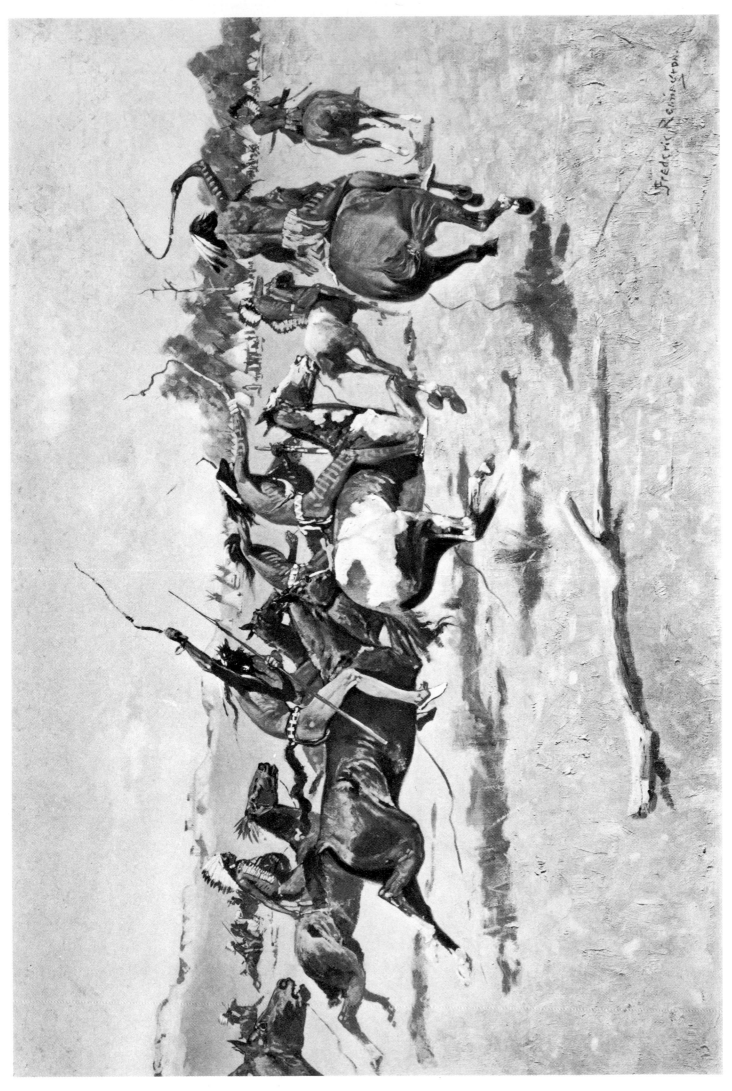

18 The Pony War-Dance

19 The Coming Storm

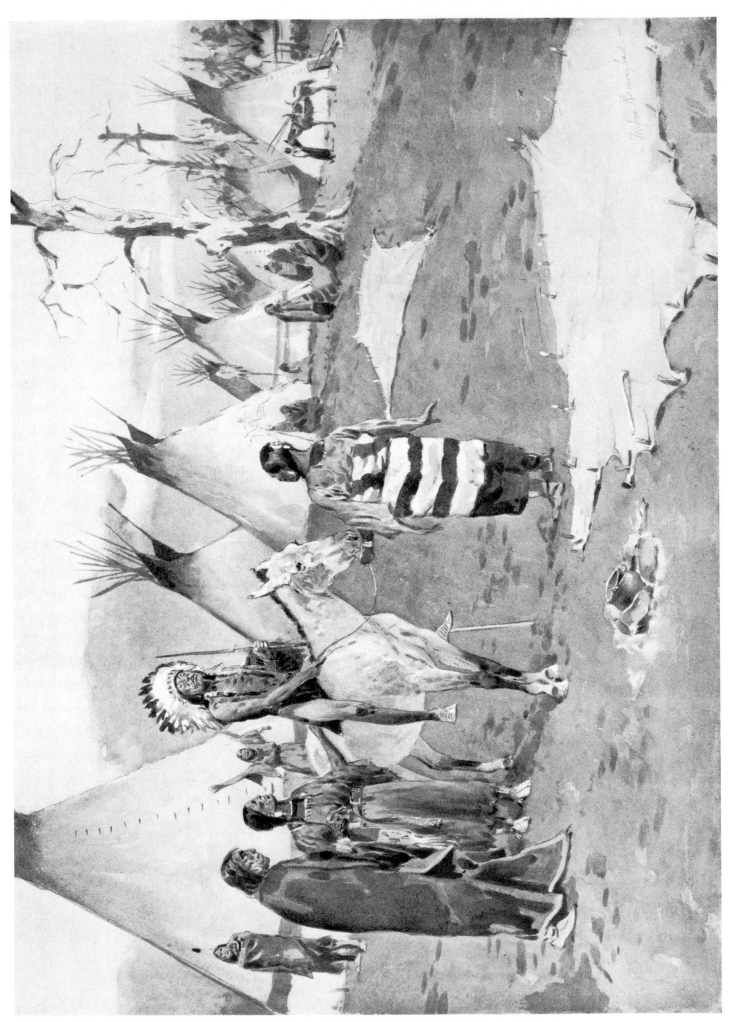

20 His Death Song

21 Protecting a Wagon Train

Frederic Remington

22 The Water in Arizona

Frederic Remington

24 A Crow Scout

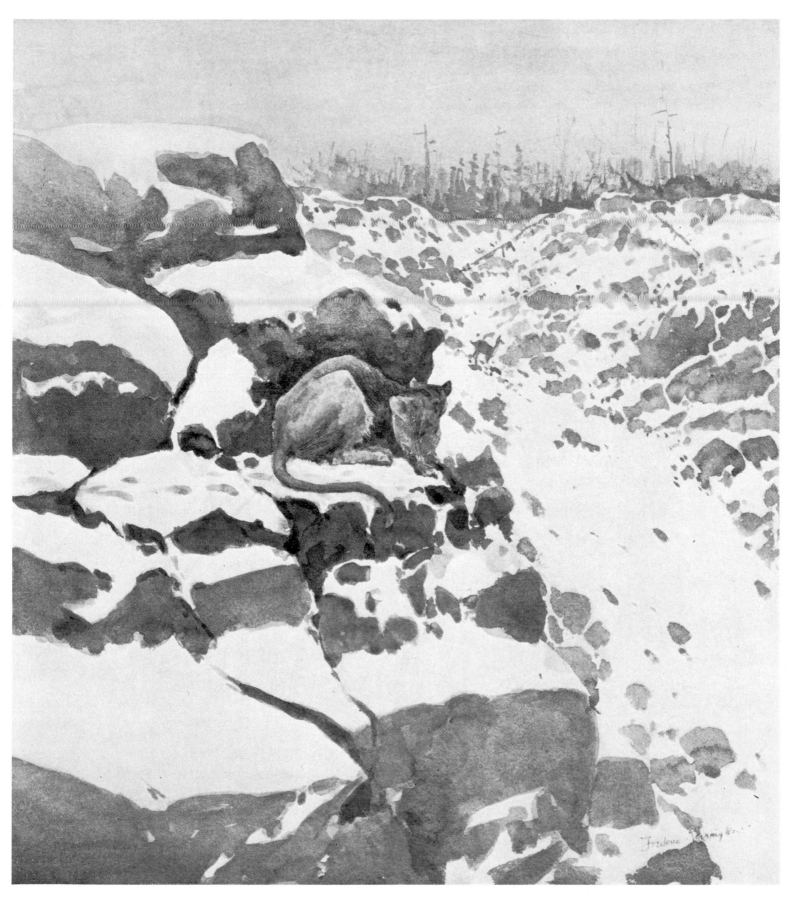

25　A Mountain Lion Hunting

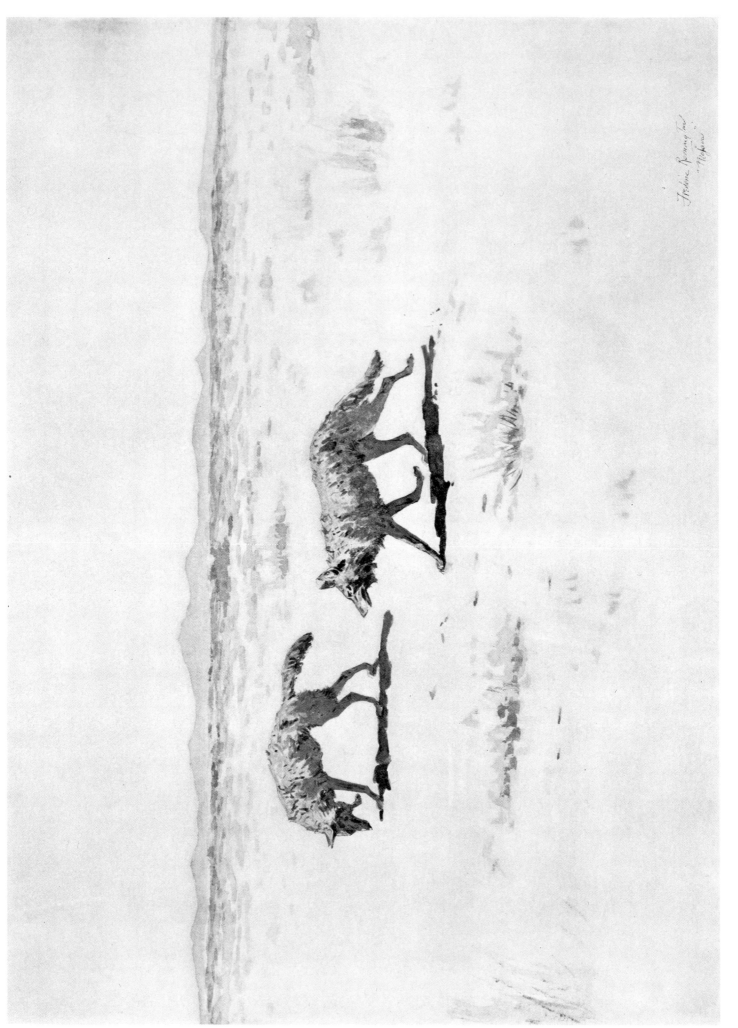

Frederic Remington
"Wolves"

26 Coyotes

27 Hostiles Watching the Column

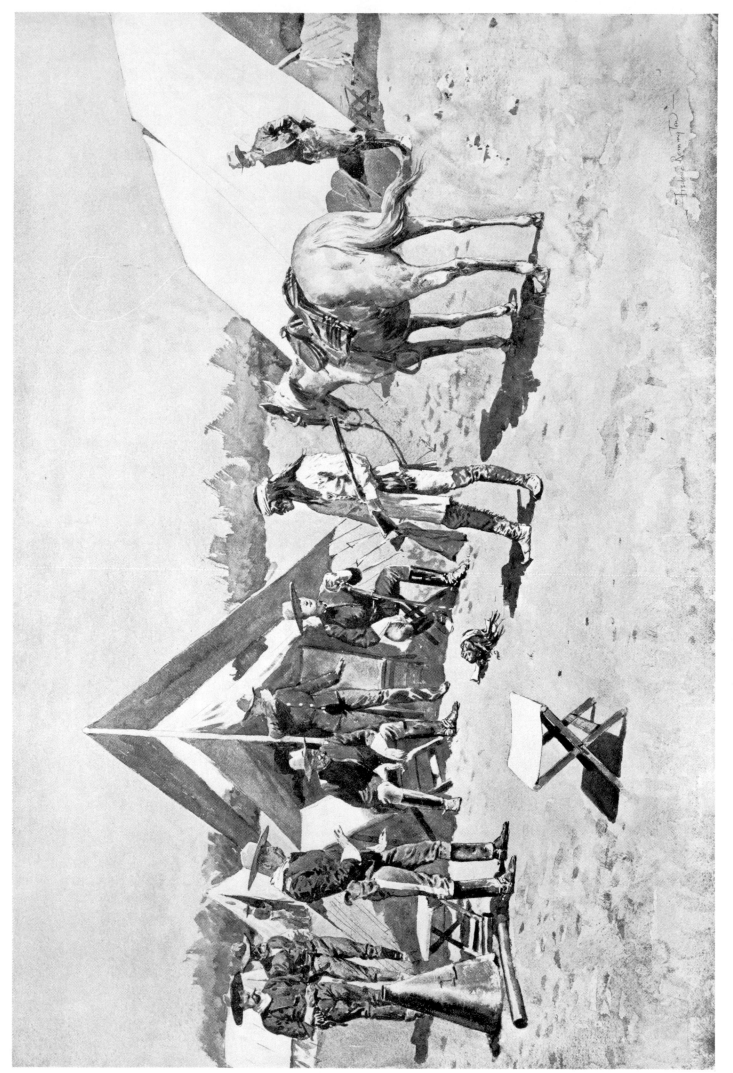

28 Satisfying the Demands of Justice::The Head

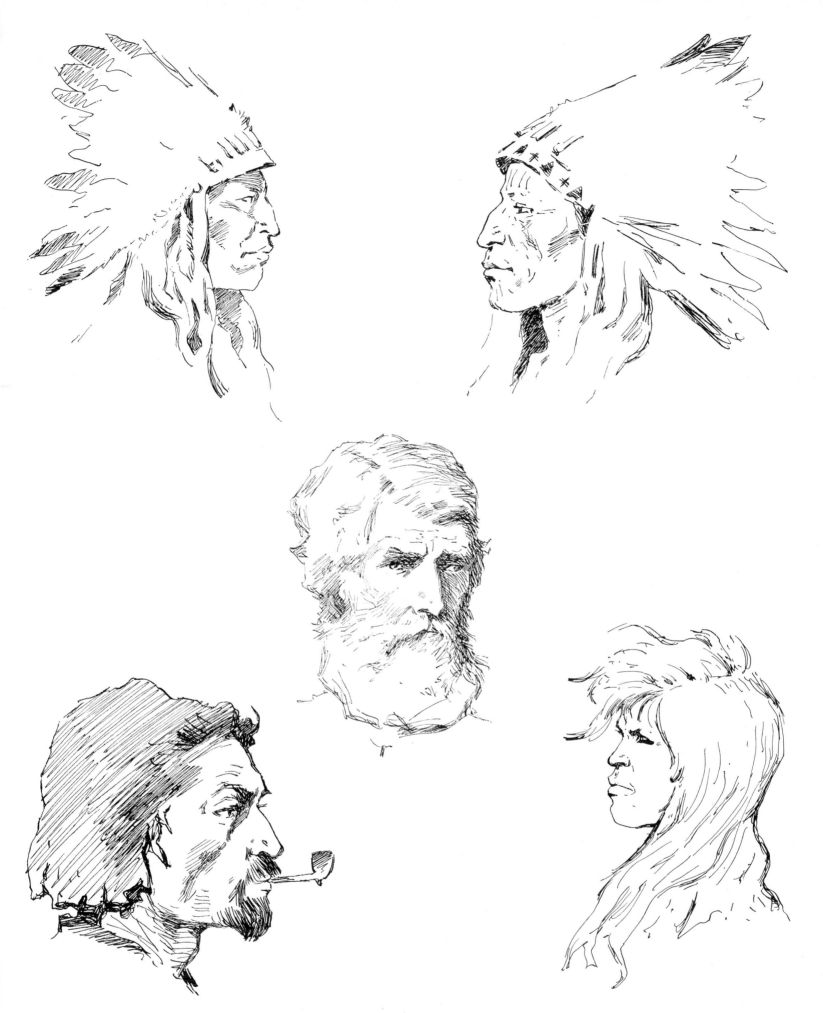

29 Sketch-Book Notes

31 Riding Herd in the Rain

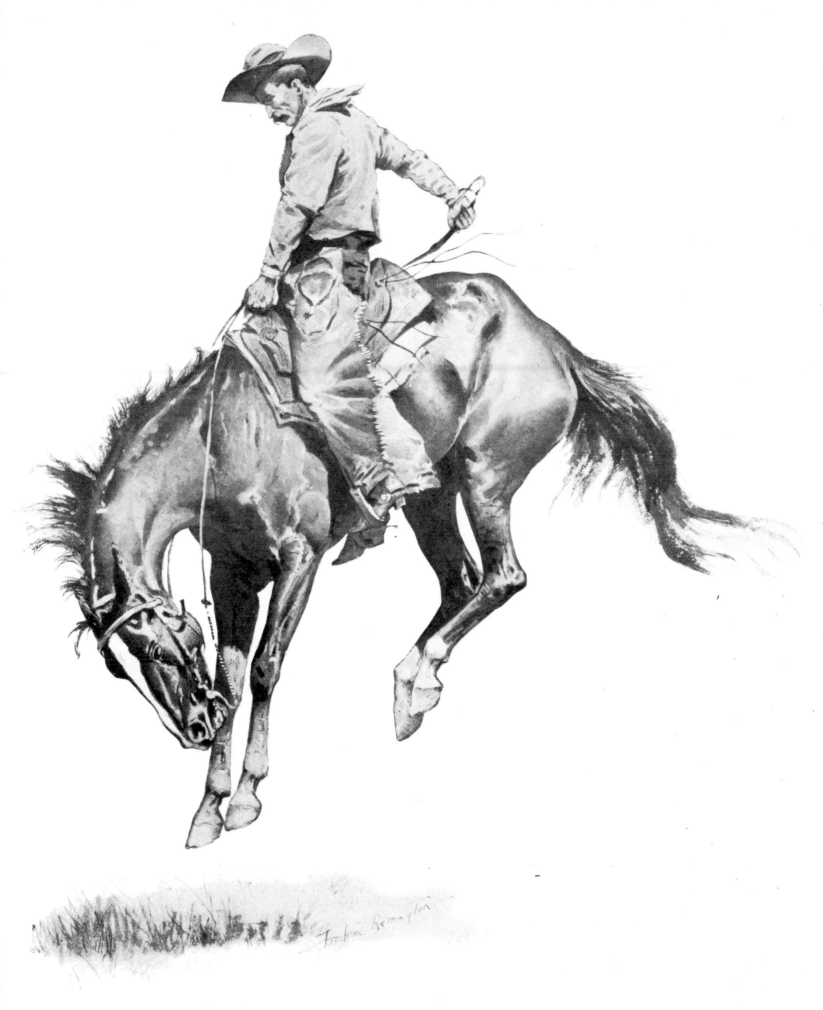

33 A "Sun Fisher"

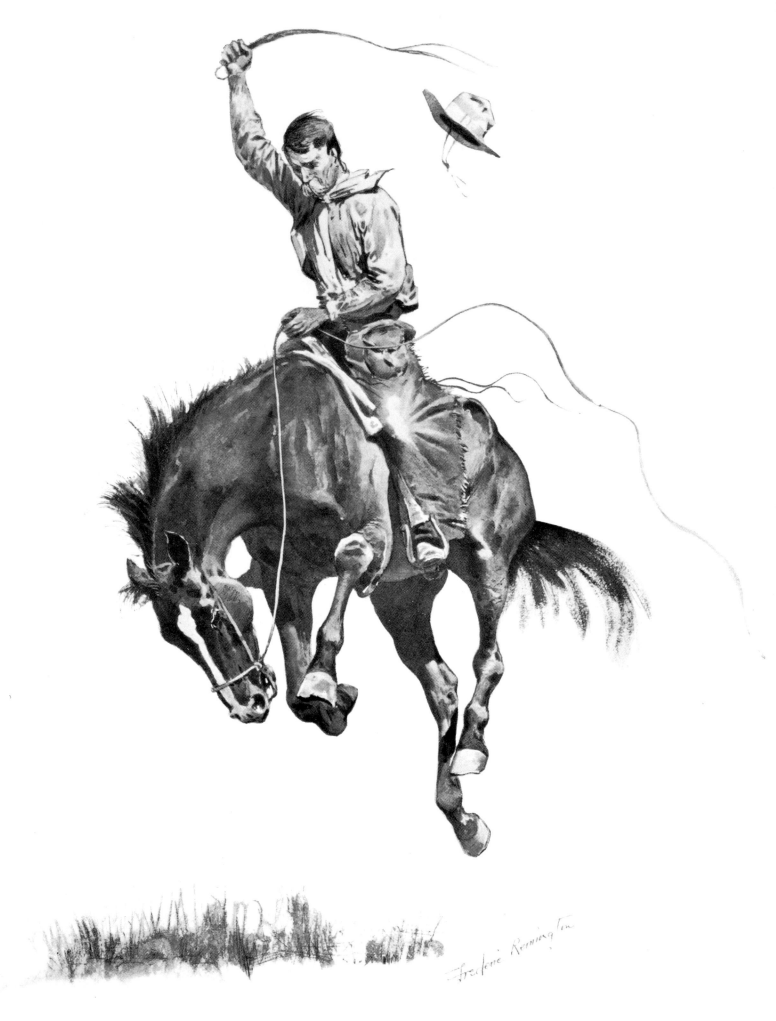

34 A Running Bucker

35 Riding the Range—Winter

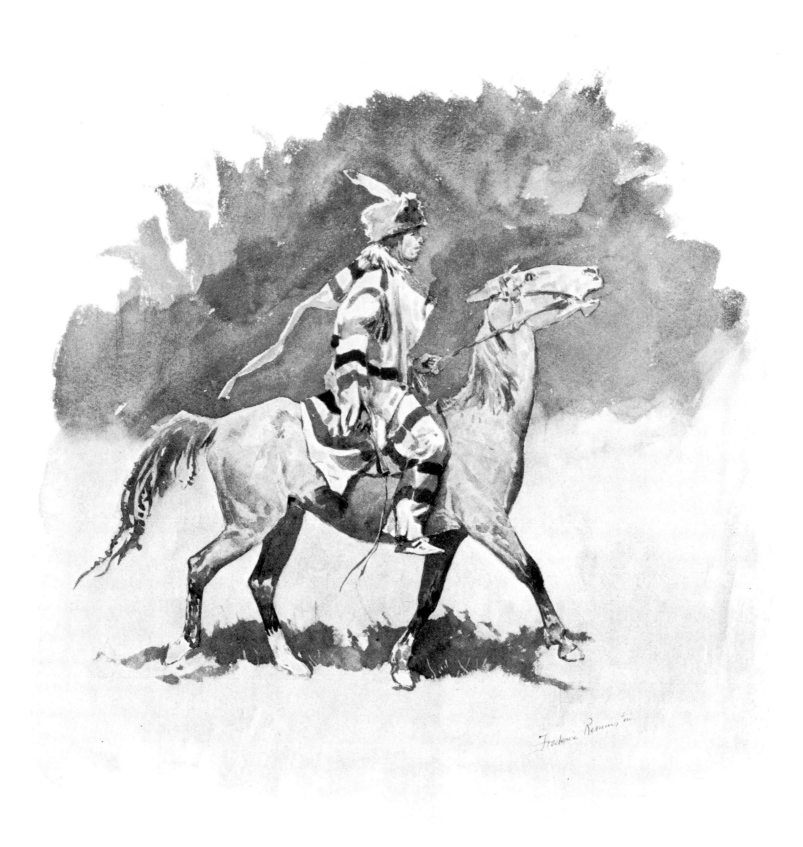

36 Snow Indian, or the Northwest Type

37 Nez Percé Indian

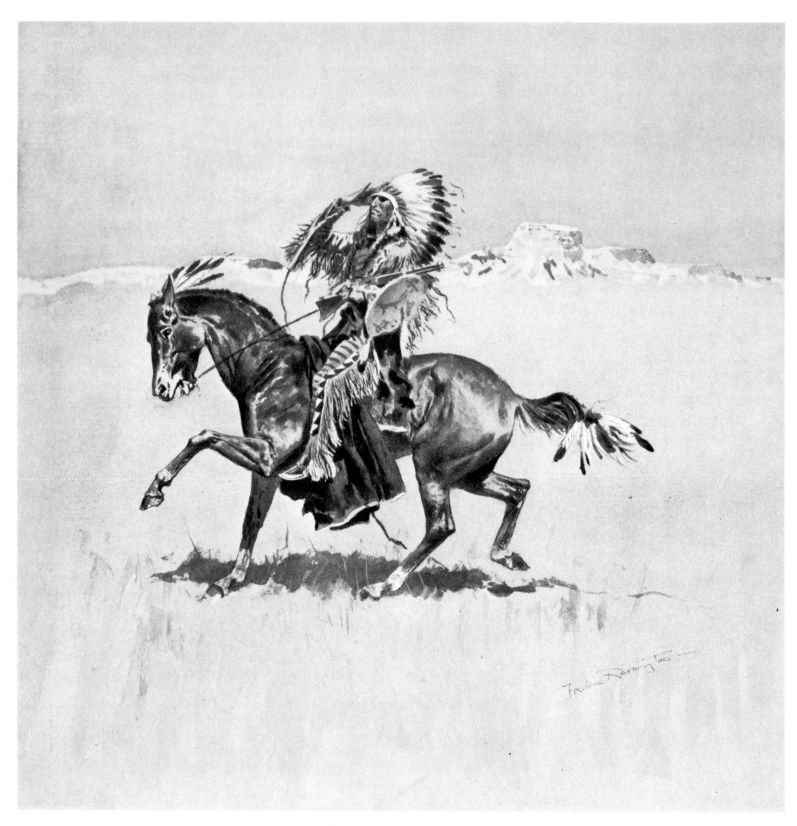

38 A Cheyenne Warrior

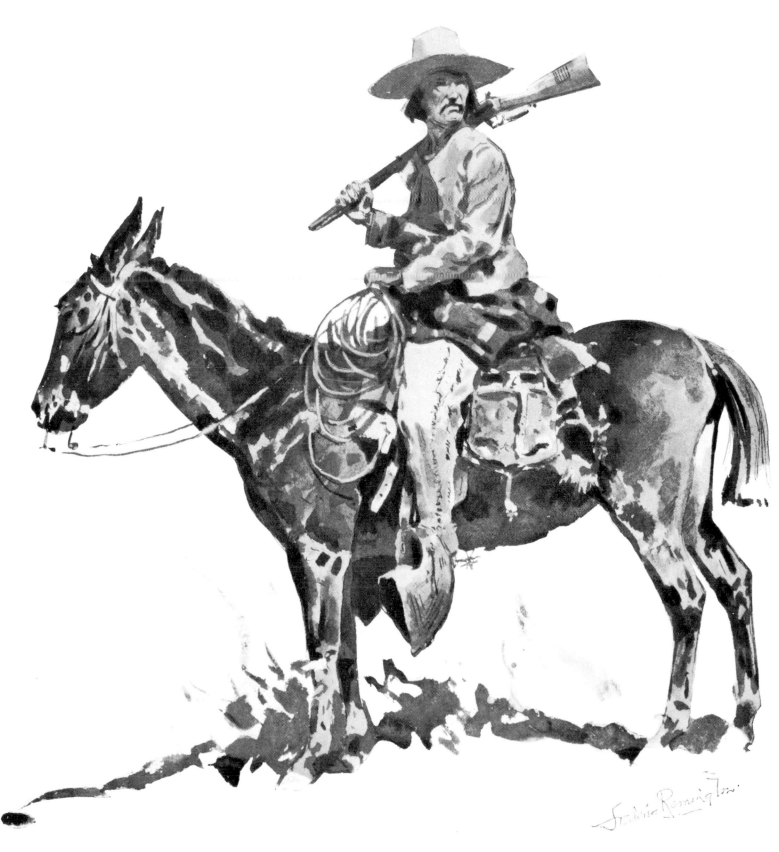

39 A Greaser

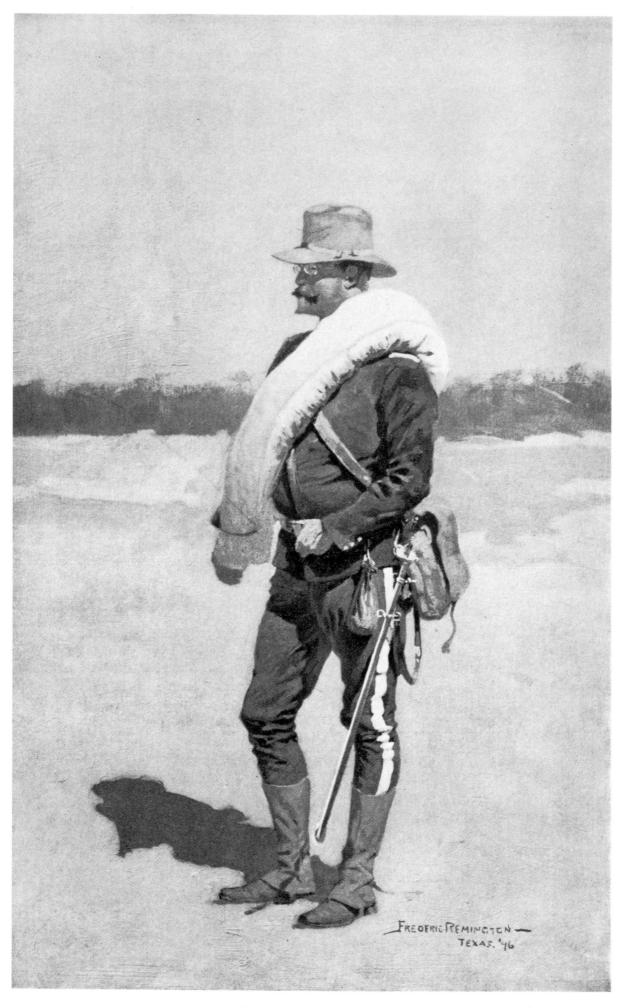

40 A Captain of Infantry in Field Rig

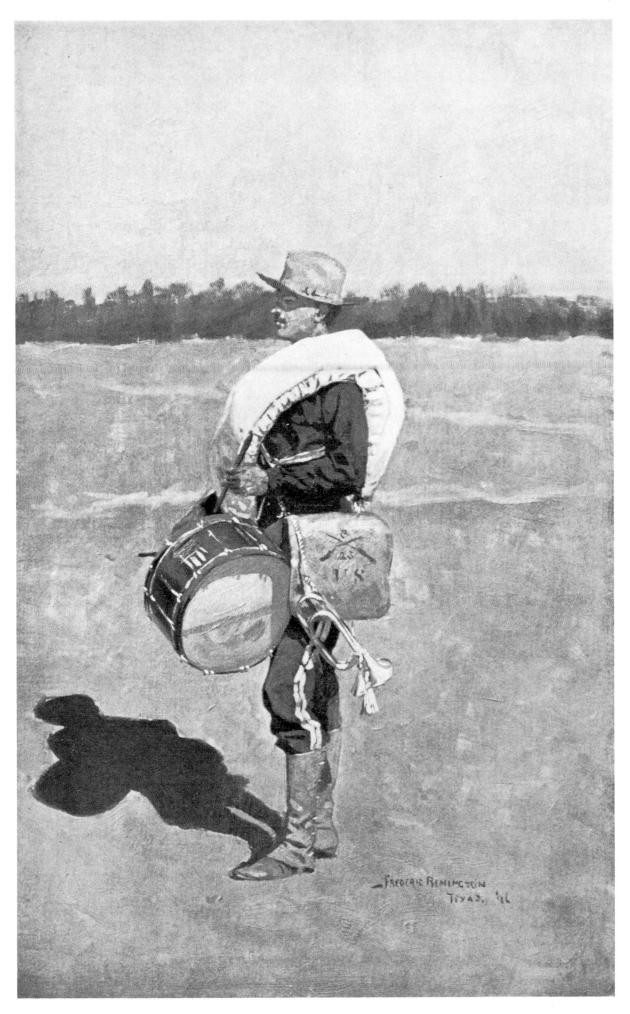

41 A "Wind Jammer"

42 Cavalry Column out of Forage

43 Half-Breed Horse Thieves of the Northwest

44 A Misdeal

45 Over the Foot-Hills

46 Taking the Robe

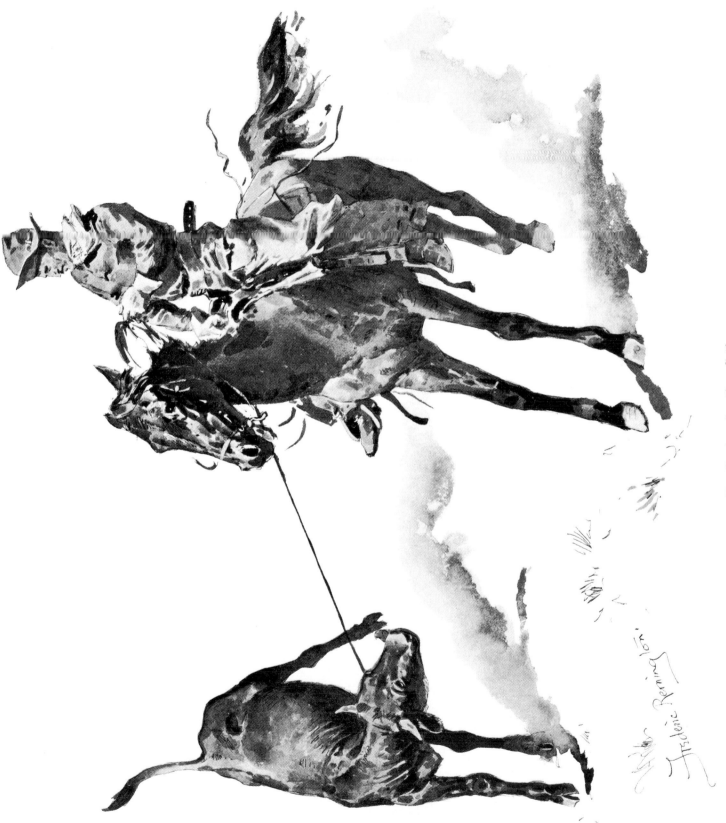

47 Cowboy Leading Calf

Fredric Remington.

48 Cow Pony Pathos

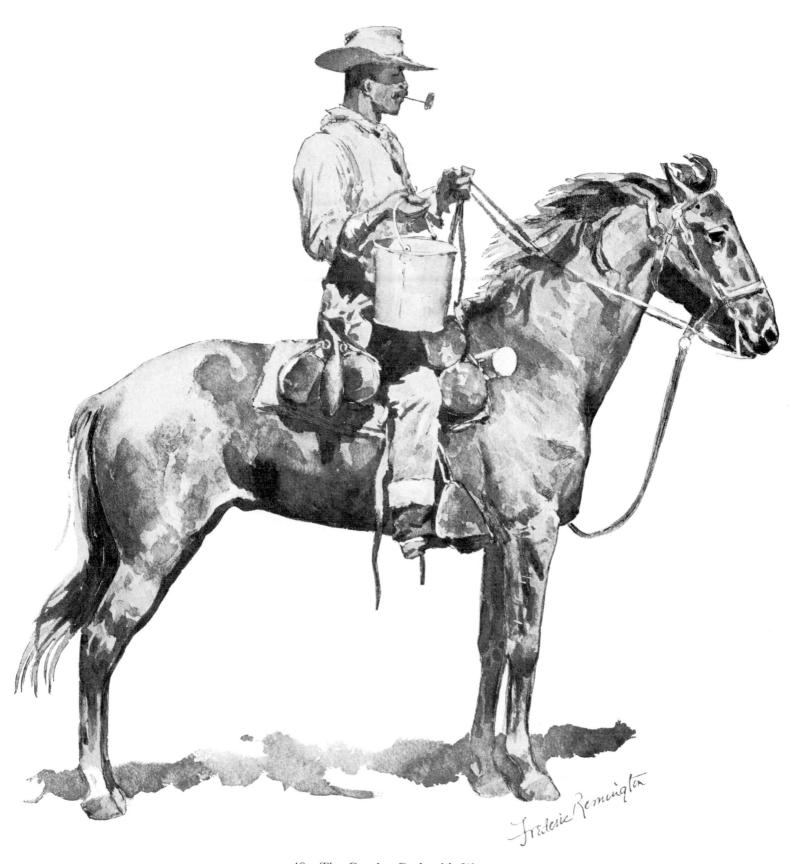

49 The Cavalry Cook with Water

50 A Modern Cavalry Camp

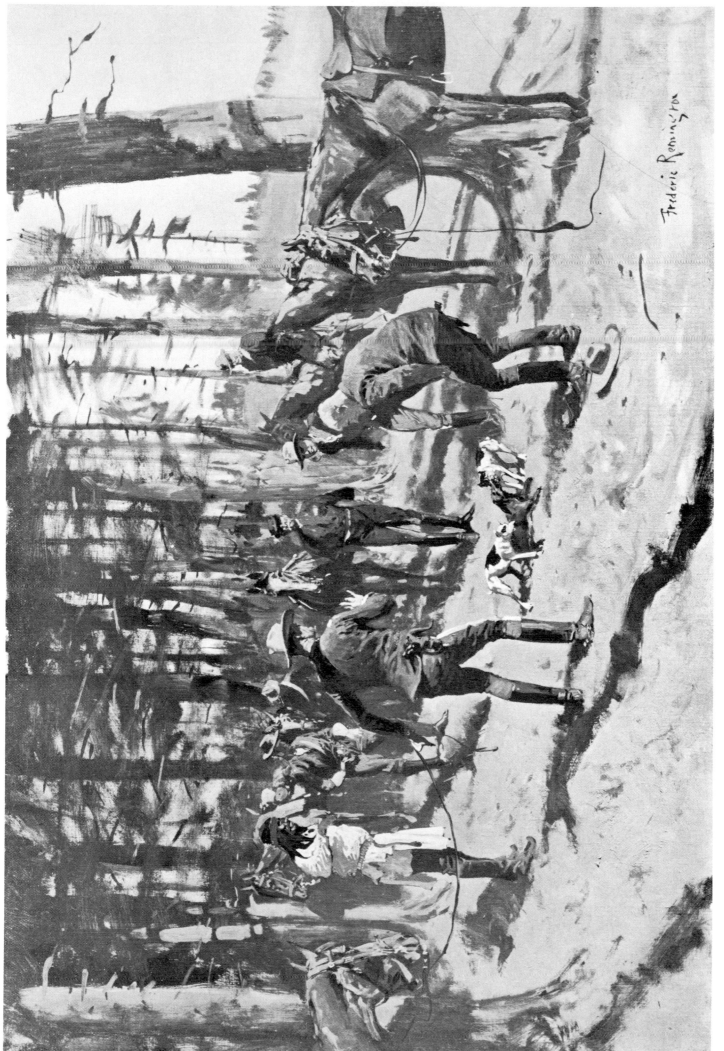

51 Fox Terriers Fighting a Badger

52 High Finance at the Cross-Roads

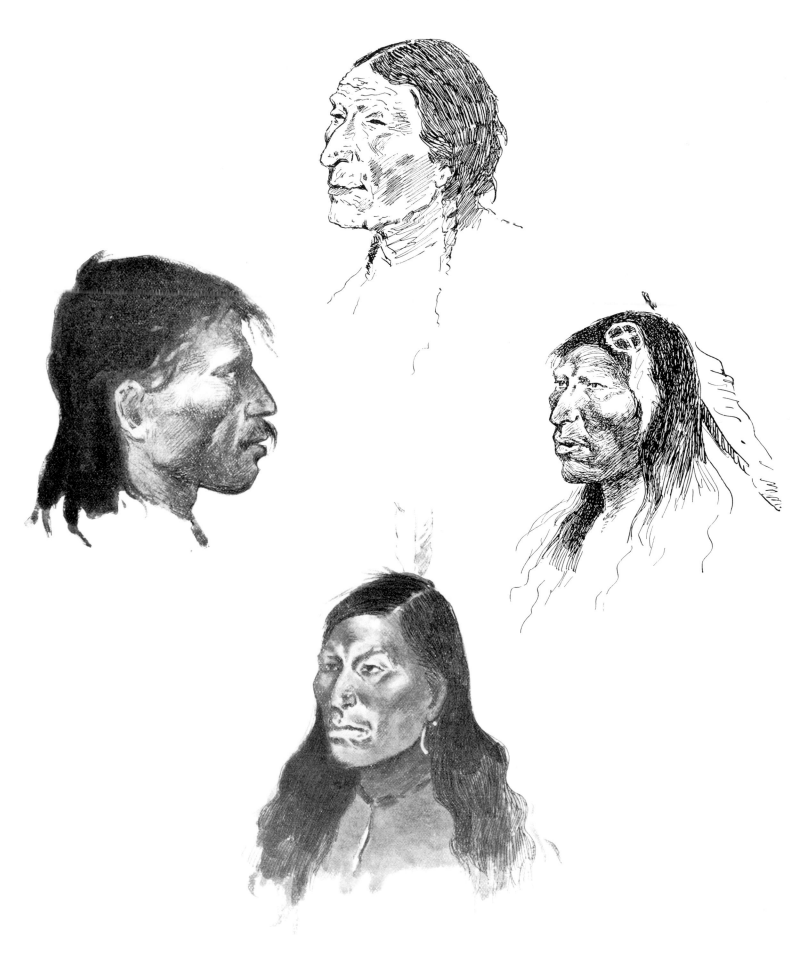

53 Sketch-Book Notes

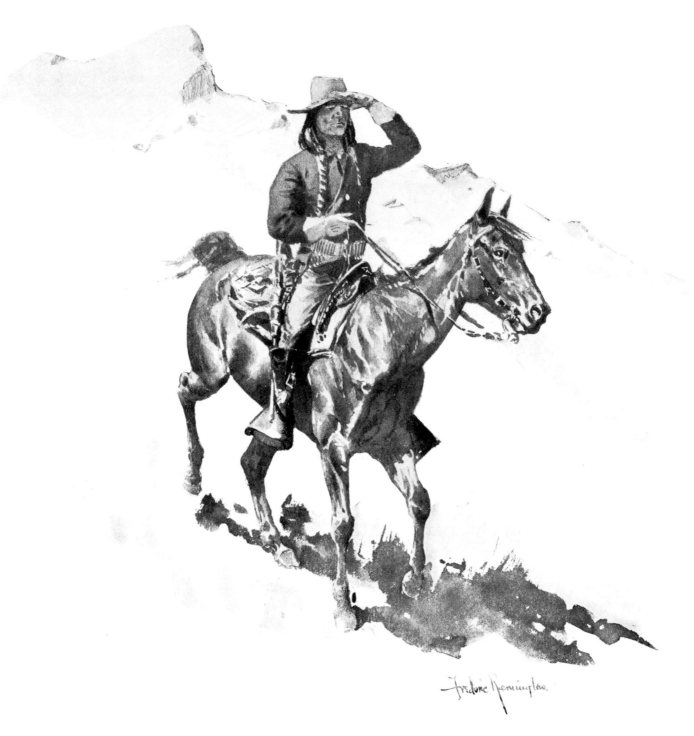

54 The Indian Soldier

55 The Squaw Pony

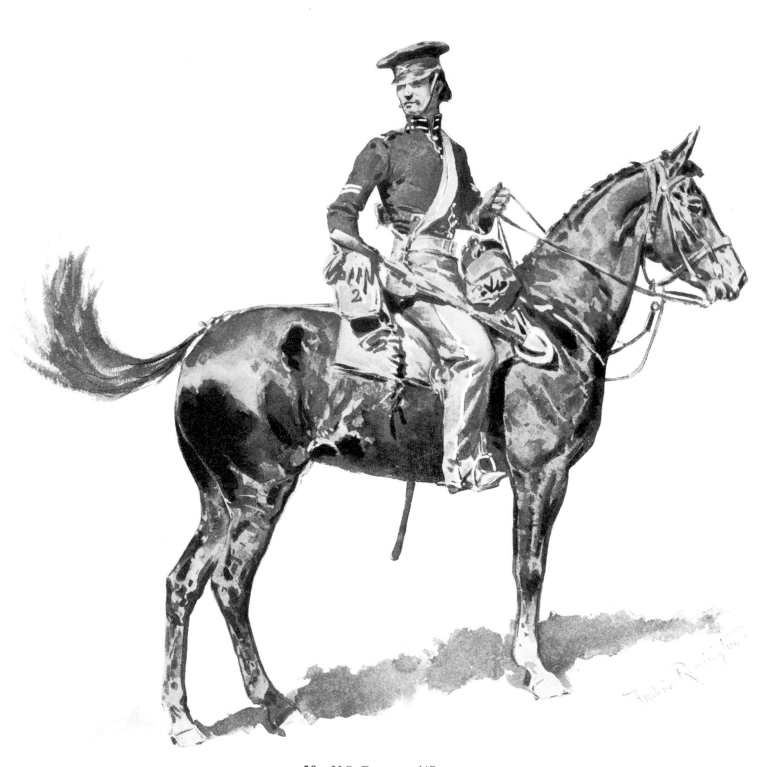

56 U.S. Dragoon, '47

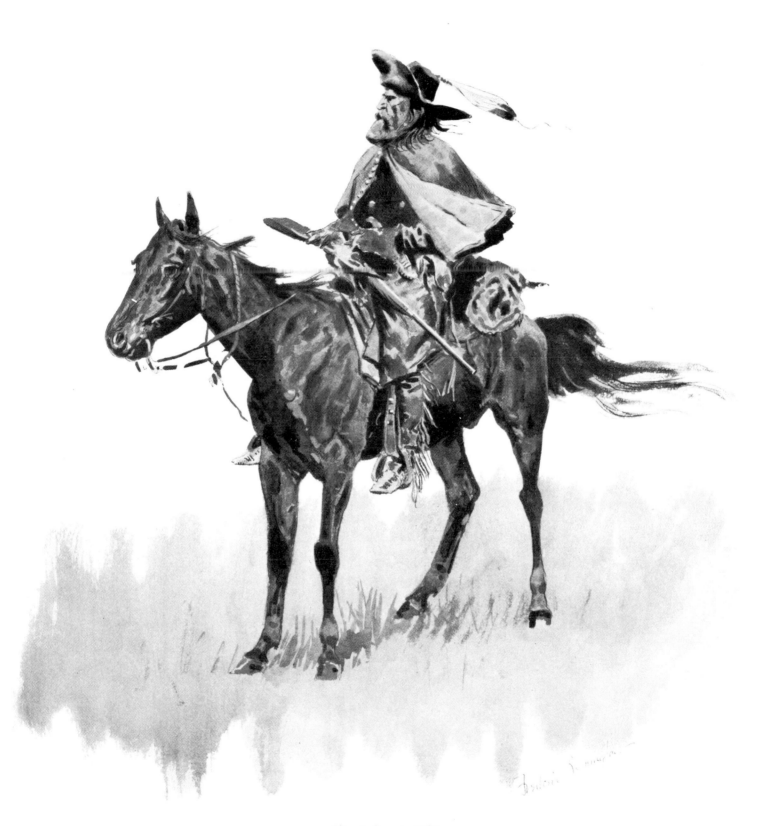

57 A Scout, 1868

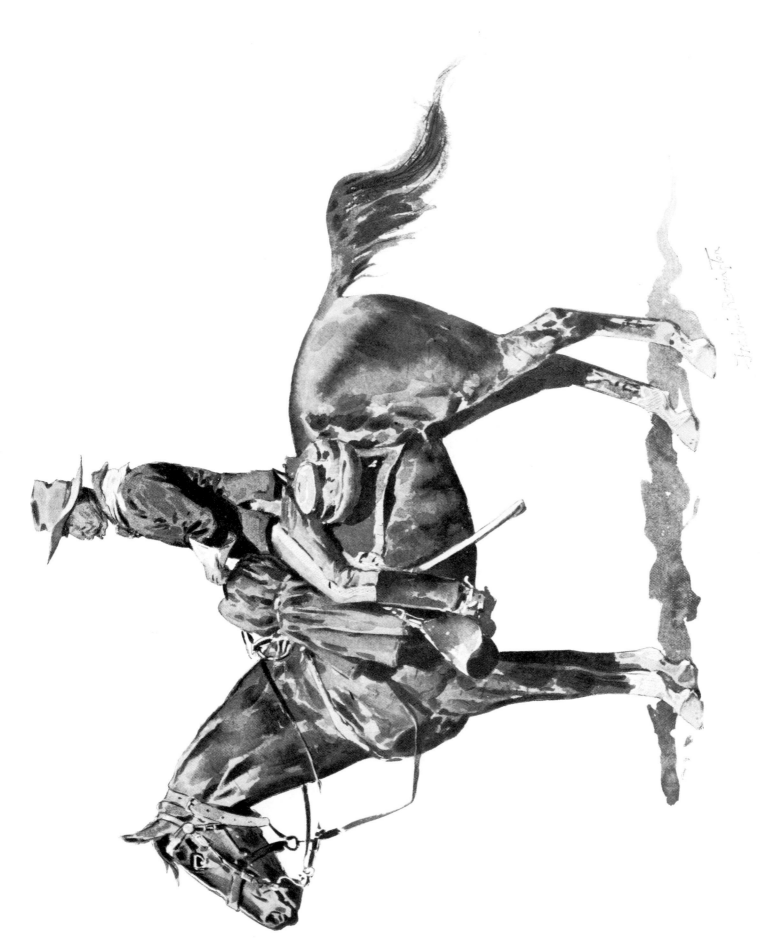

58 U.S. Cavalry Officer on Campaign

59 A Reservation Indian

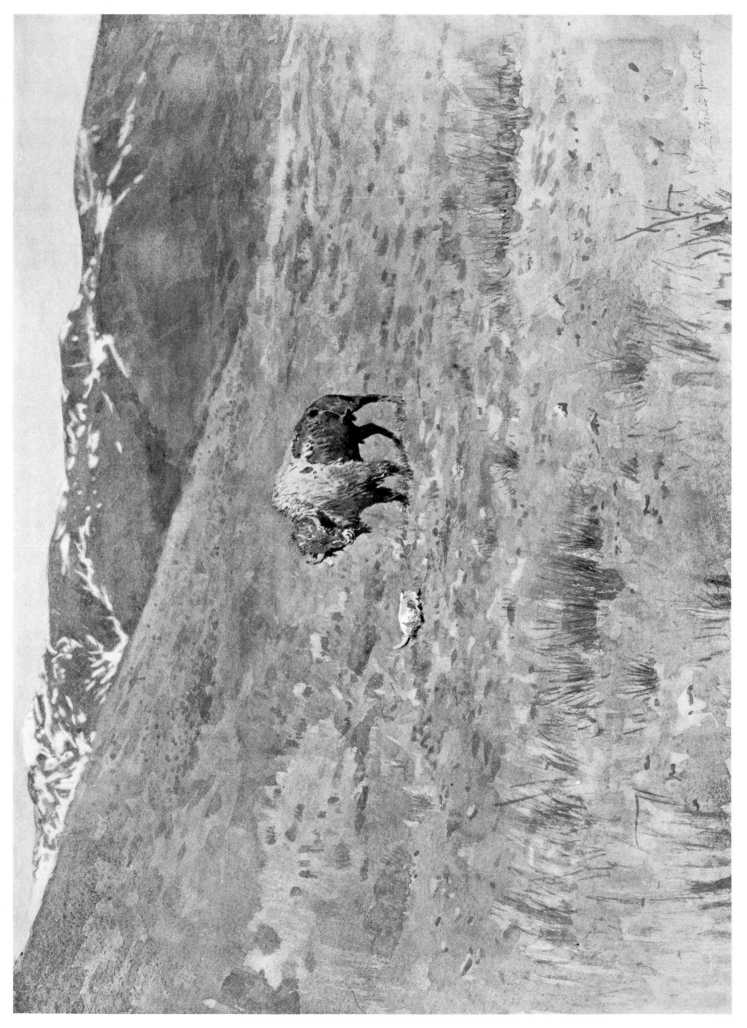

61 The Twilight of the Indian

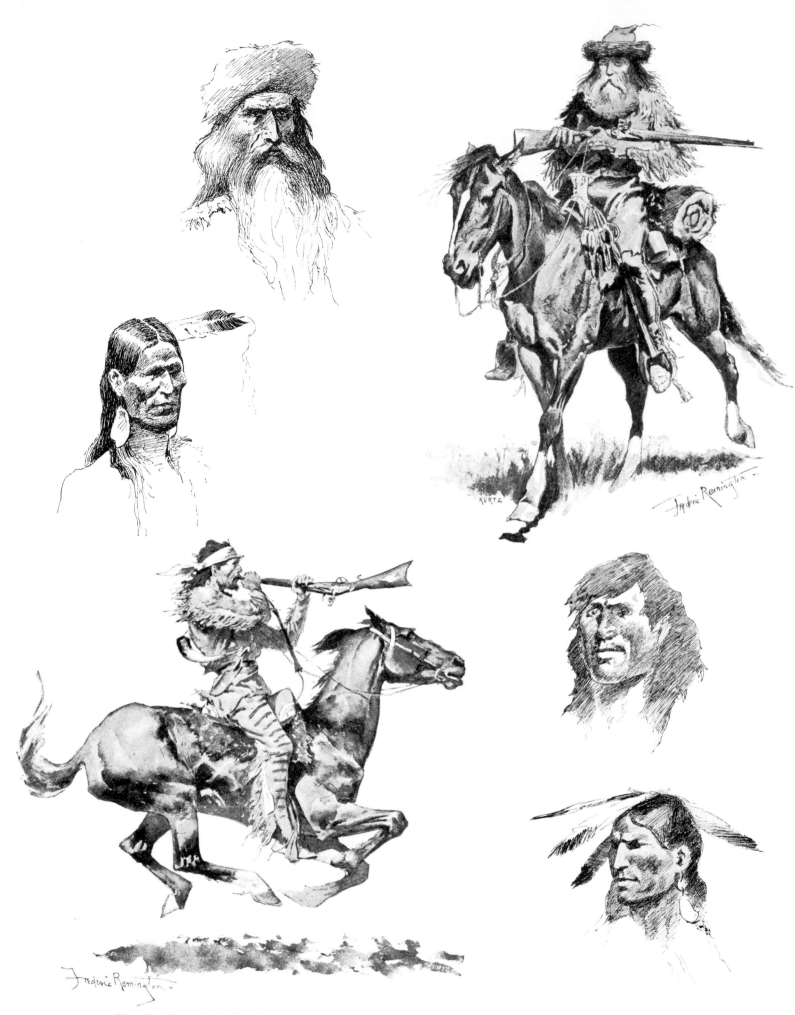

62 Old Reynal; Buffalo Hunter at Full Gallop Loading His Gun with His Mouth; Studies of Heads

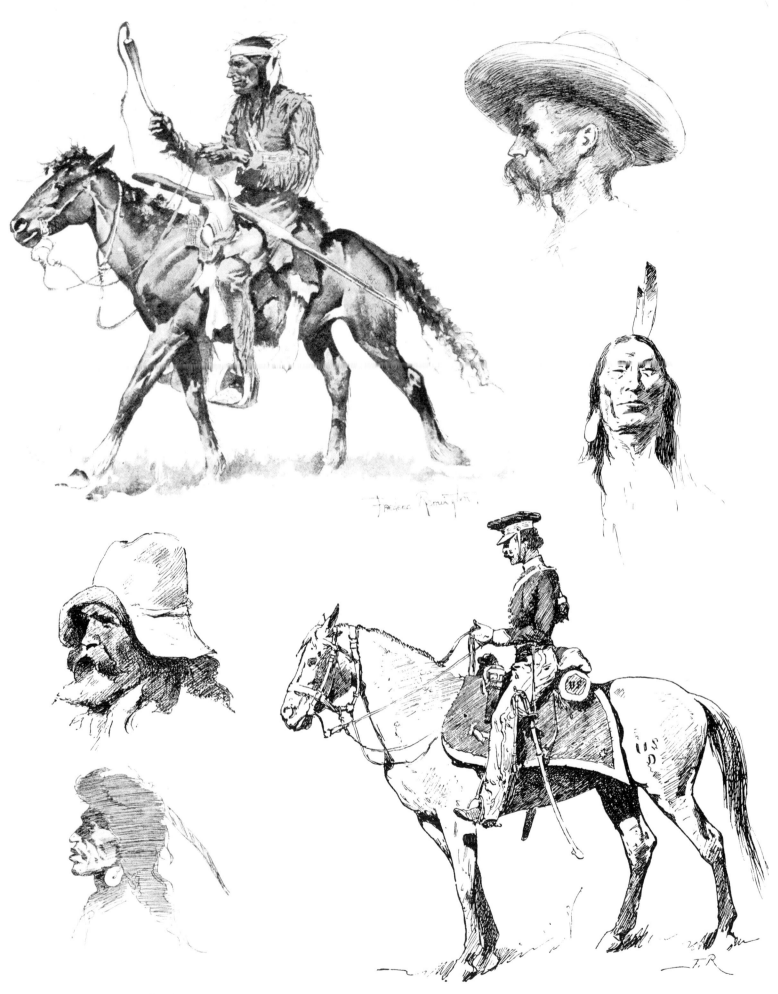

63　An Old Delaware Indian; A Cavalryman; Studies of Heads

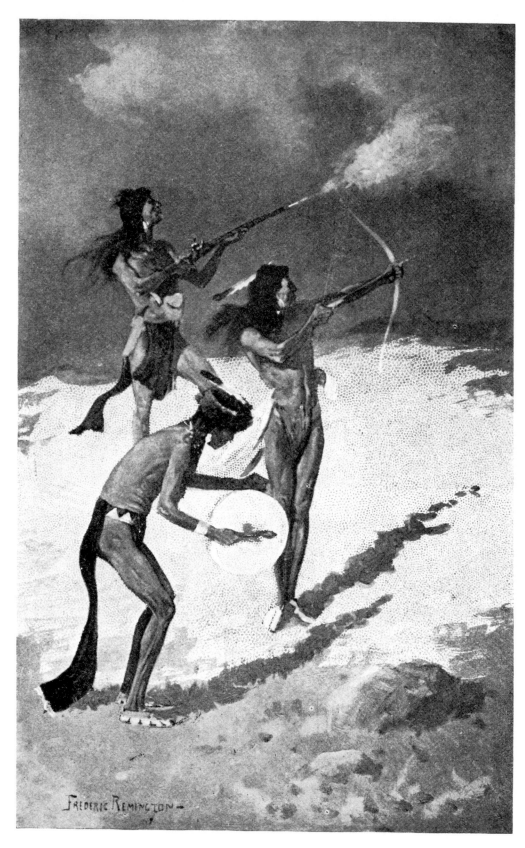

64 Thunder-Fighters Scaring off a Stormcloud

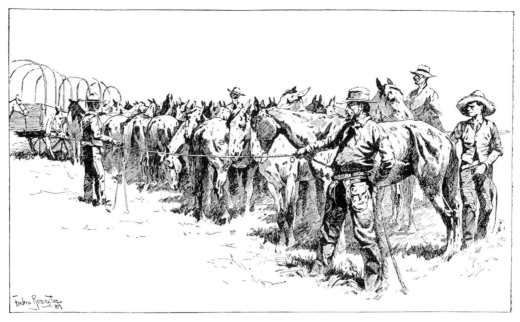

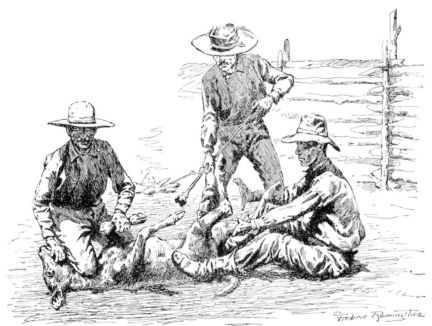

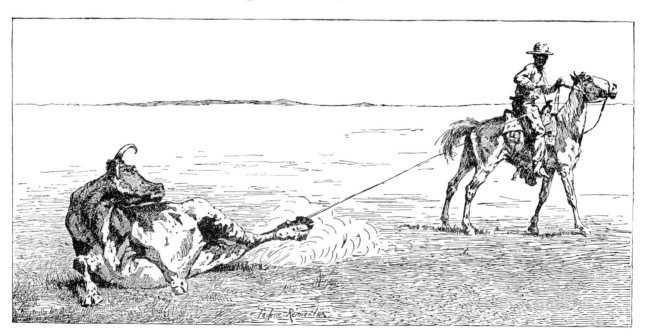

65 The Rope Corral; Branding a Calf; Roped!

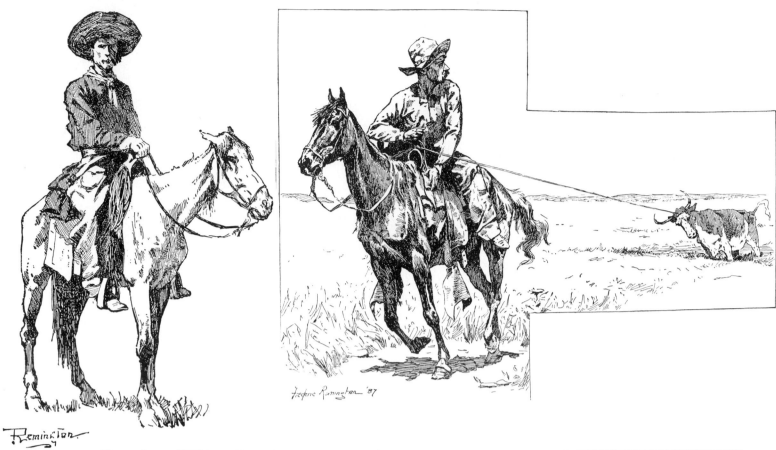

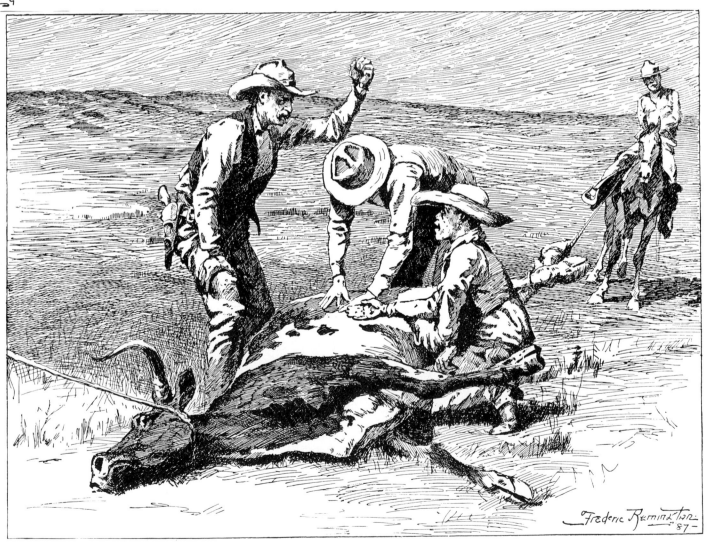

66 A Cowboy; Pulling a Cow out of the Mud; A Dispute over a Brand

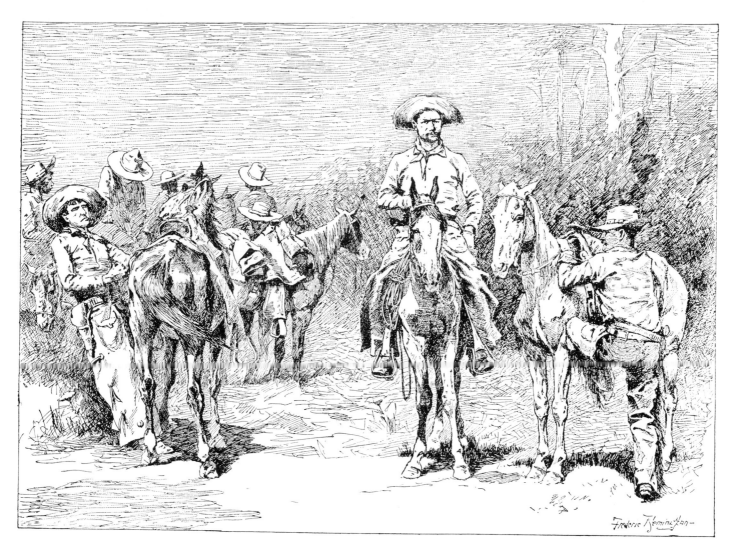

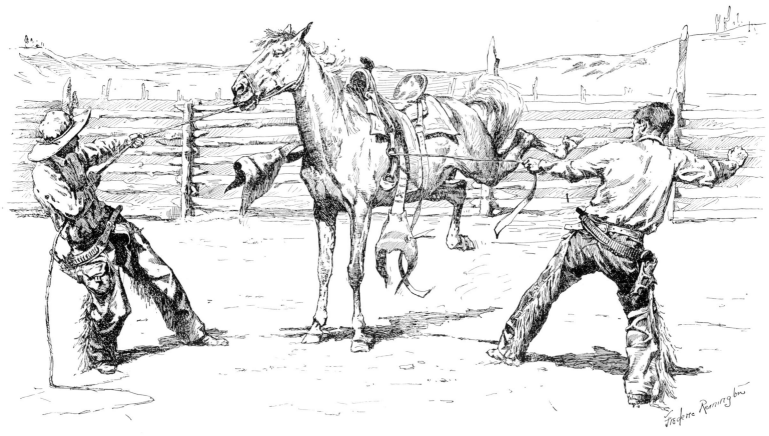

67 Saddling Fresh Horses; Bronco Busters Saddling

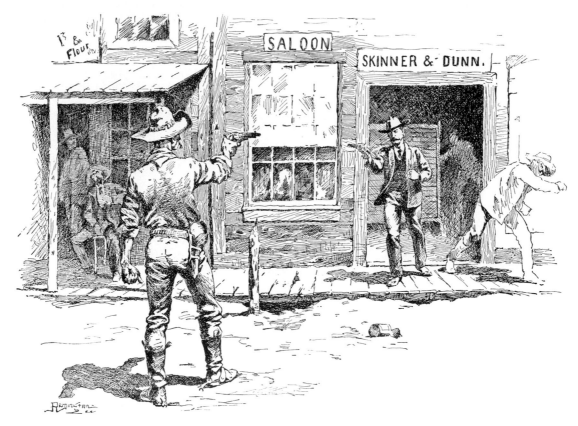

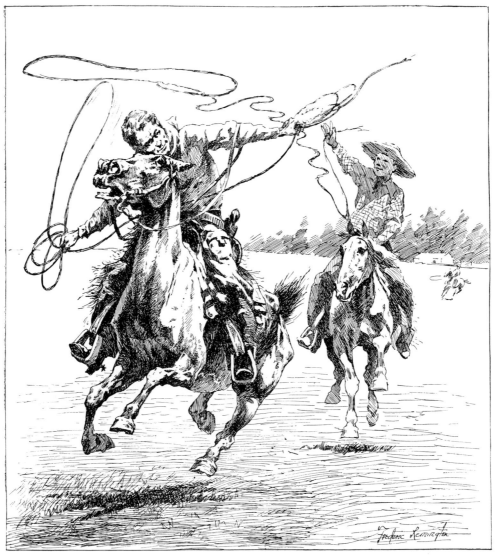

68 A Fight in the Street; Cowboy Fun

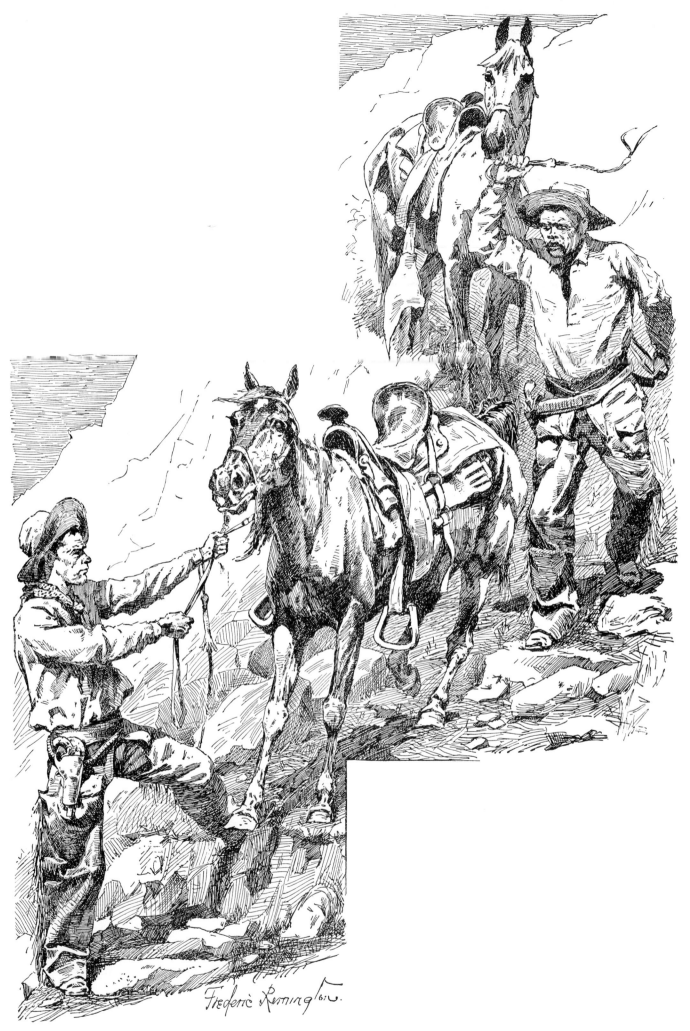

Frederic Remington.

69 A Hard Trail

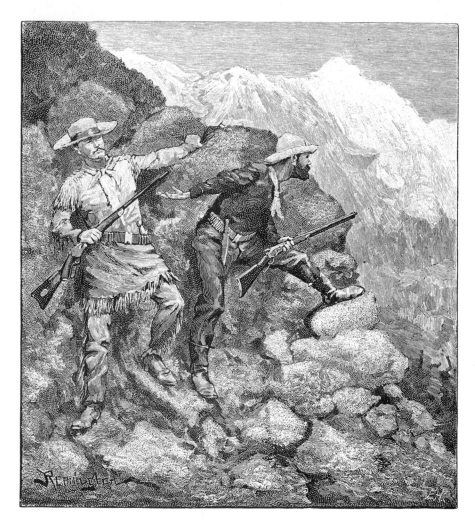

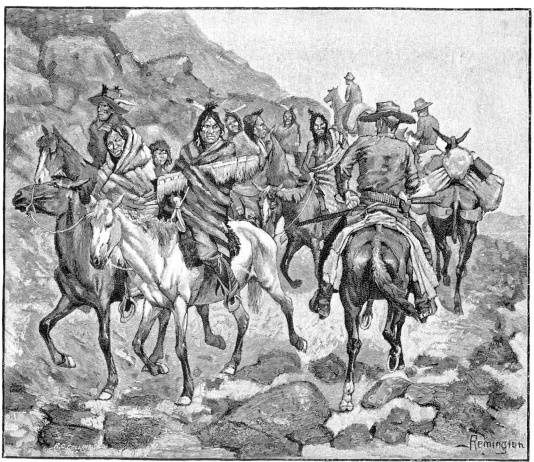

70 Stalking Goats; The Indians We Met

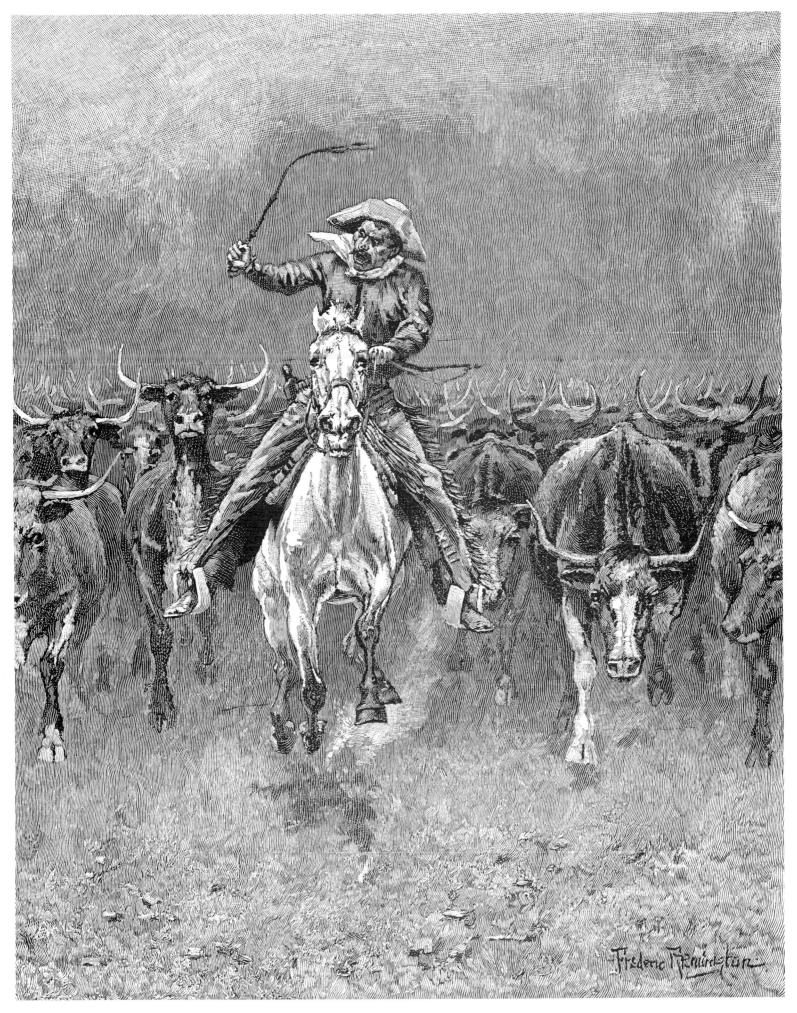

71 In a Stampede

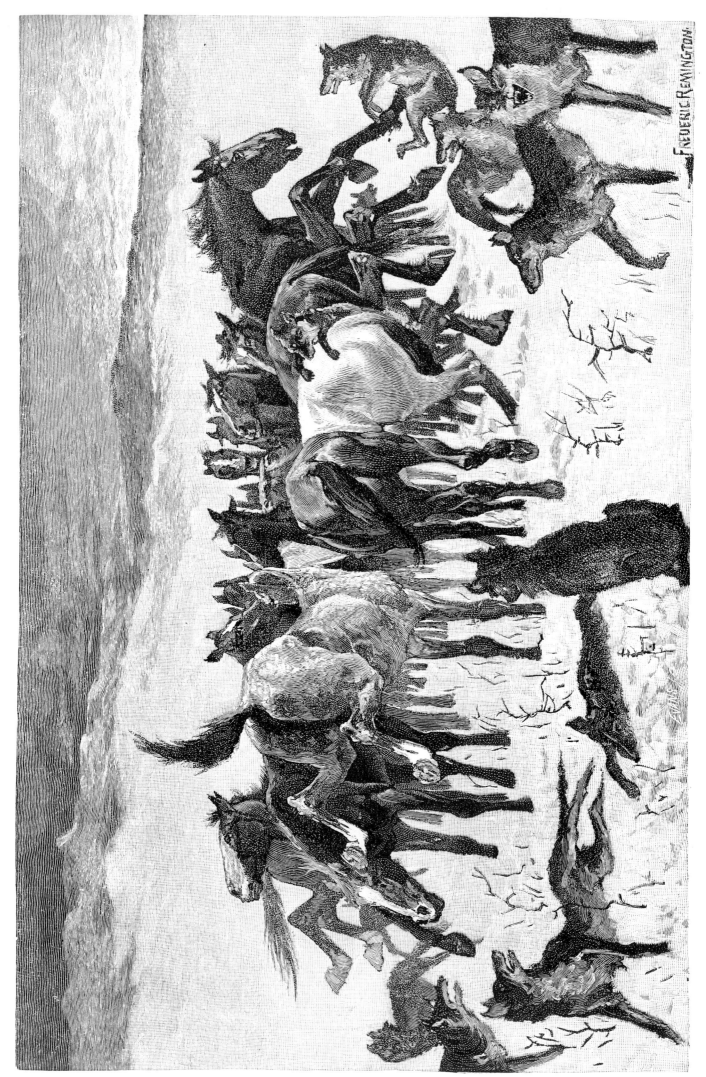

72 Broncos and Timber Wolves

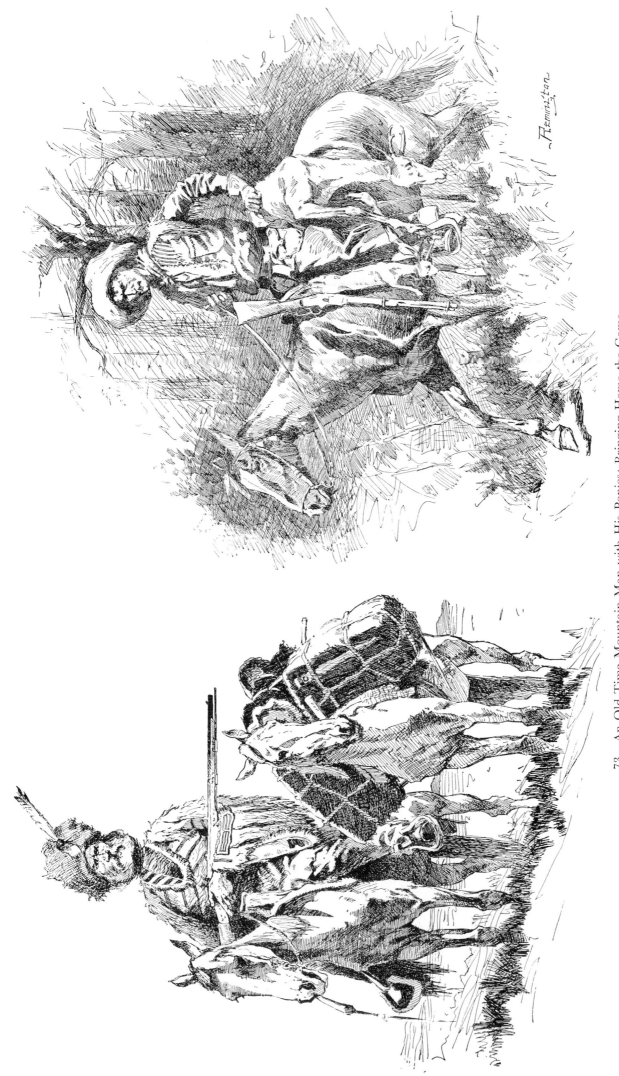

73 An Old-Time Mountain Man with His Ponies; Bringing Home the Game

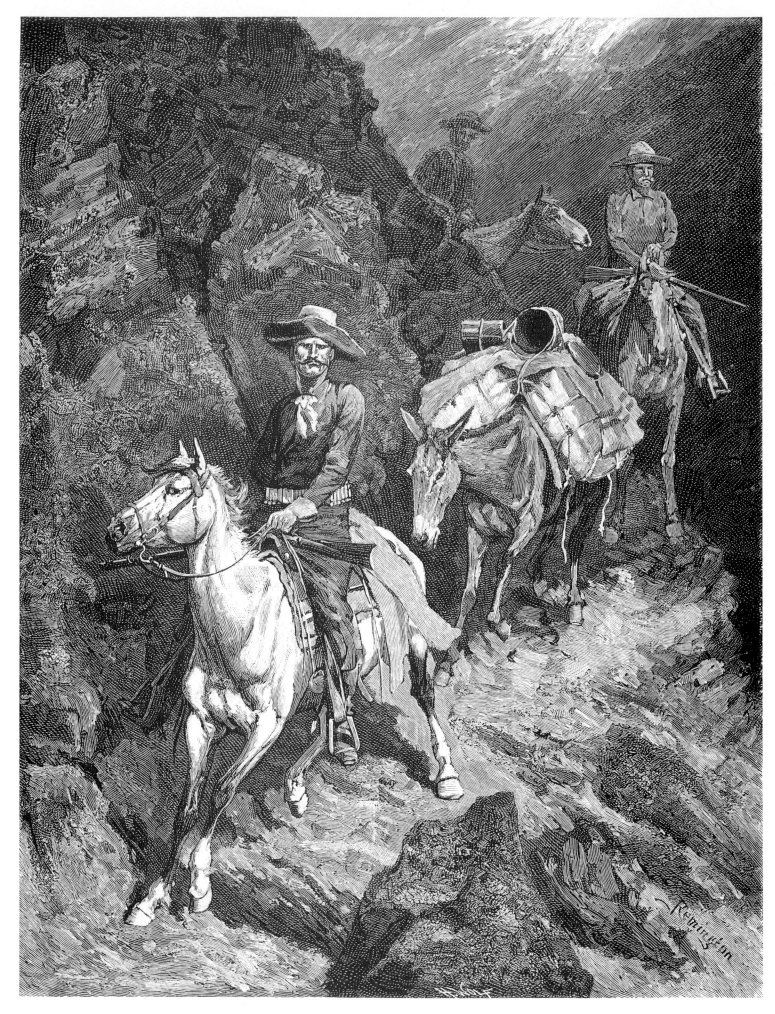

74 In a Cañon of the Cœur d'Alene

75 An Apache Indian

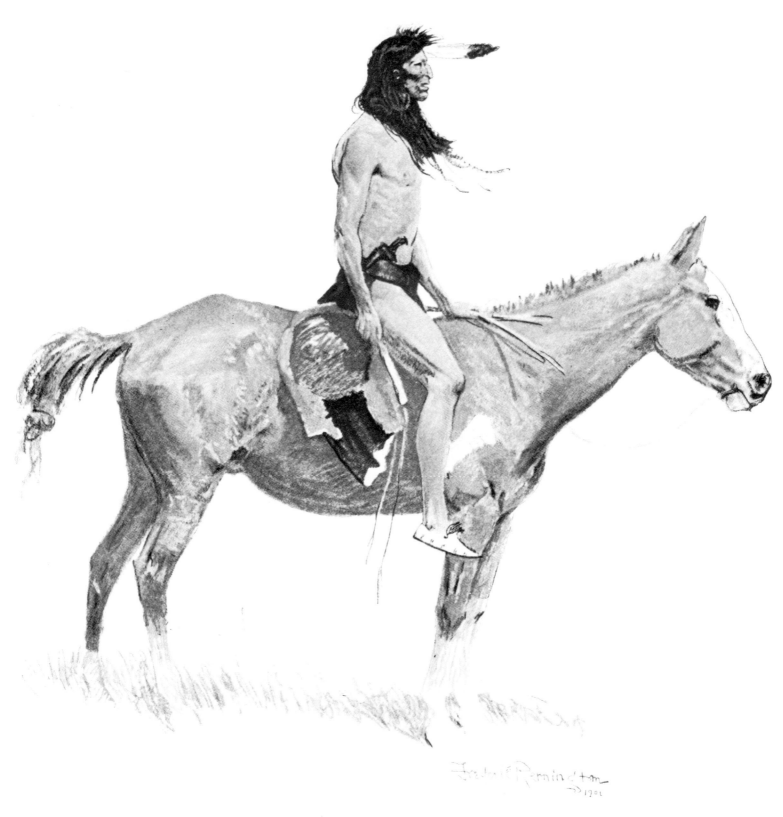

76 An Indian Brave

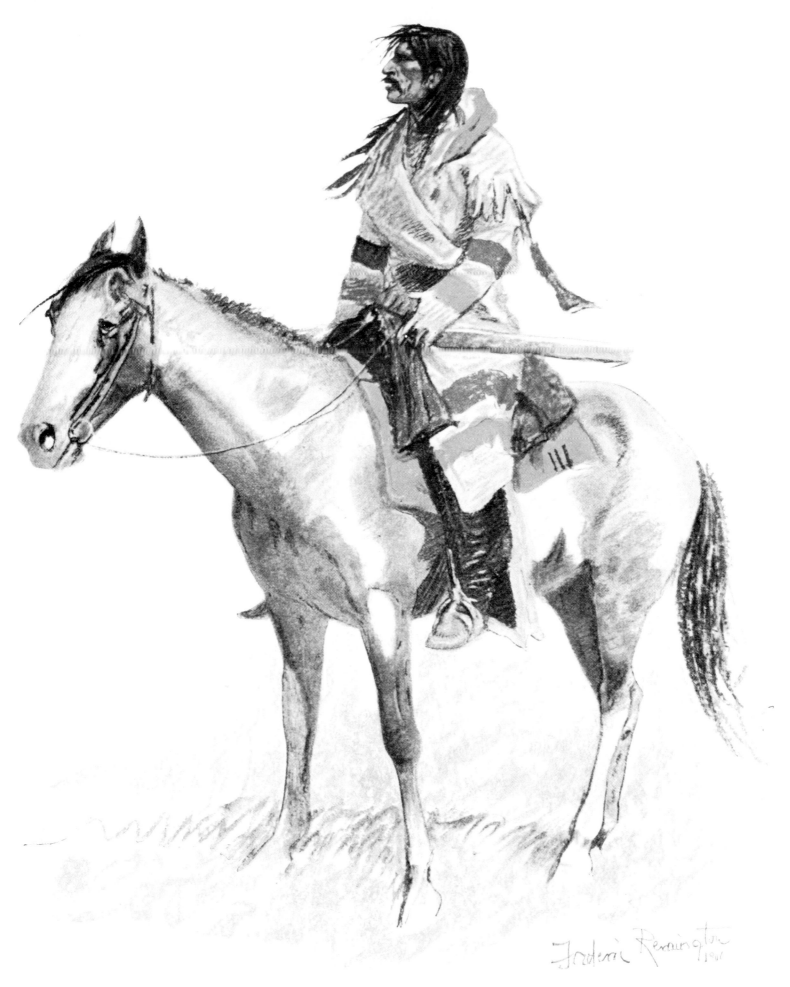

77 An Indian Scout

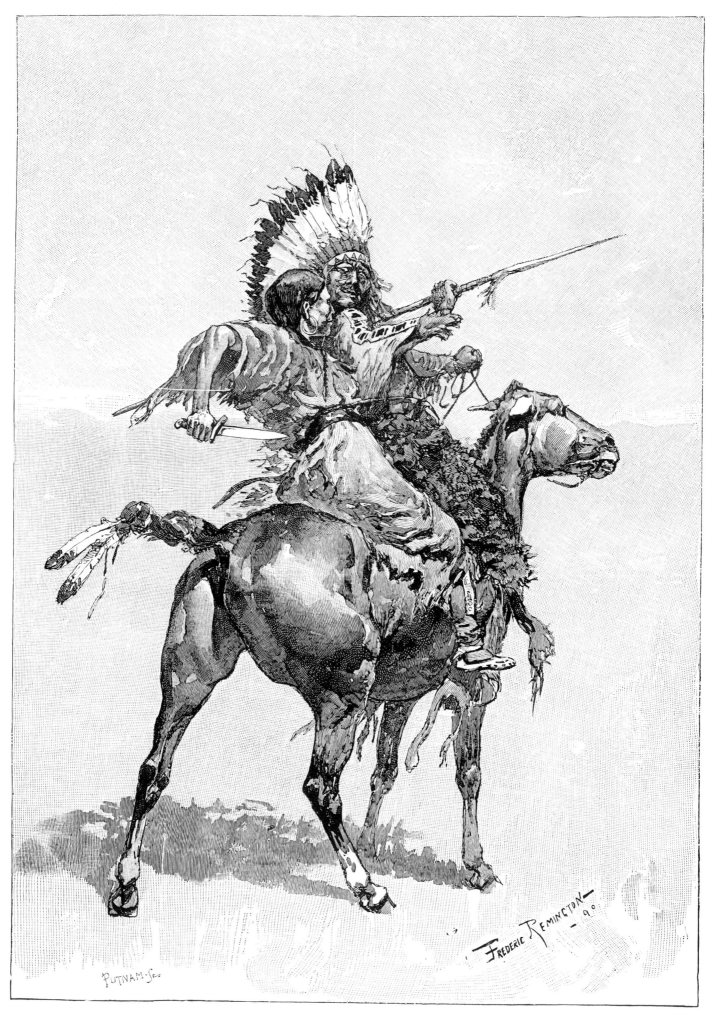

78 The Adventure of Old Sun's Wife

79 The Apaches Are Coming

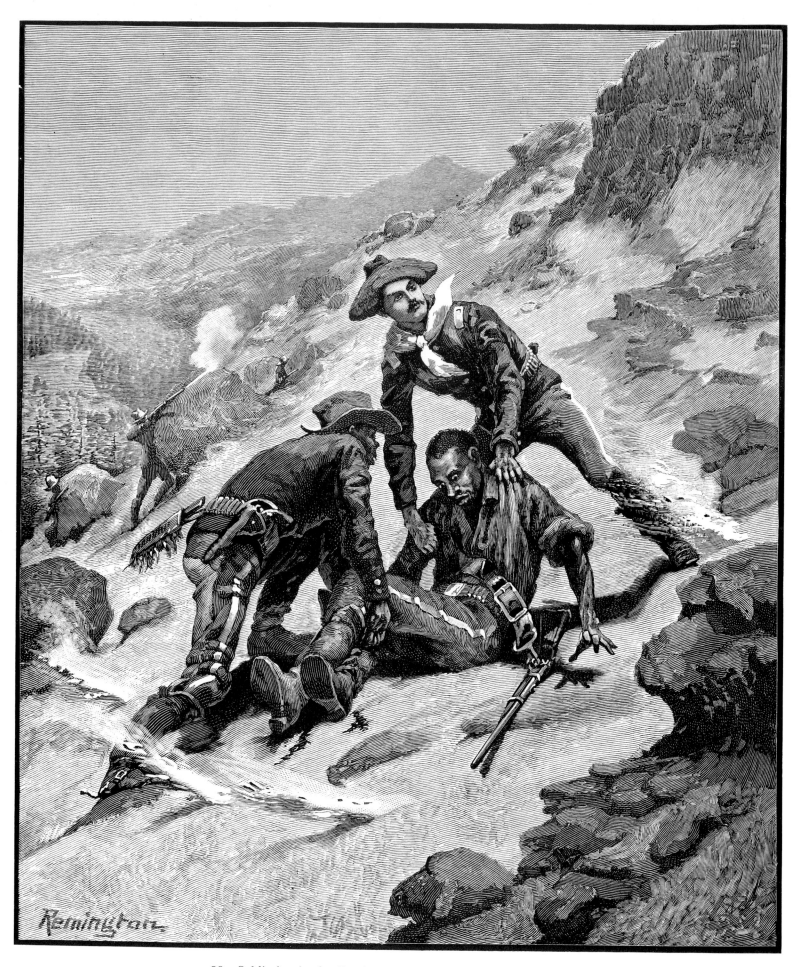

80 Soldiering in the Southwest—The Rescue of Corporal Scott

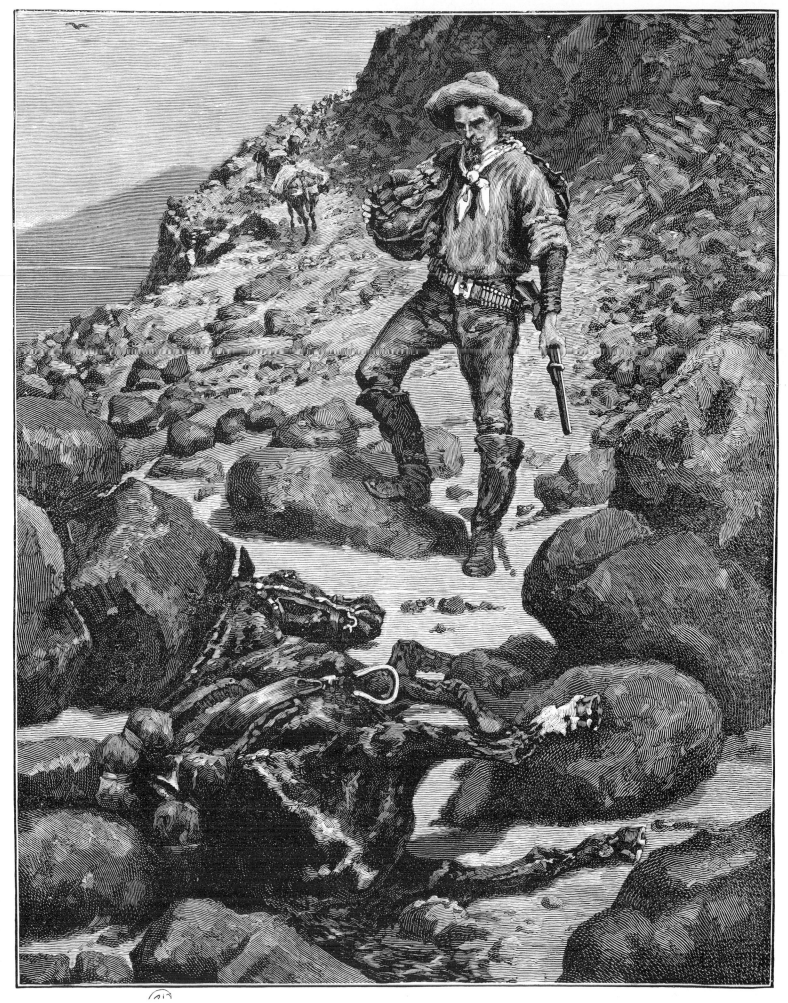

81 "Abandoned"

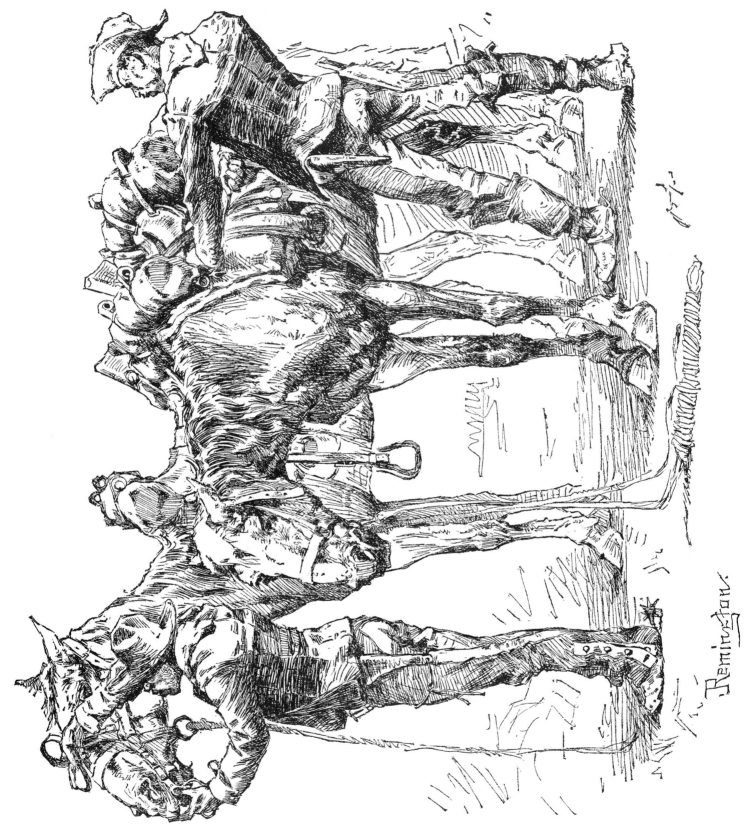

82 "Saddle Up"

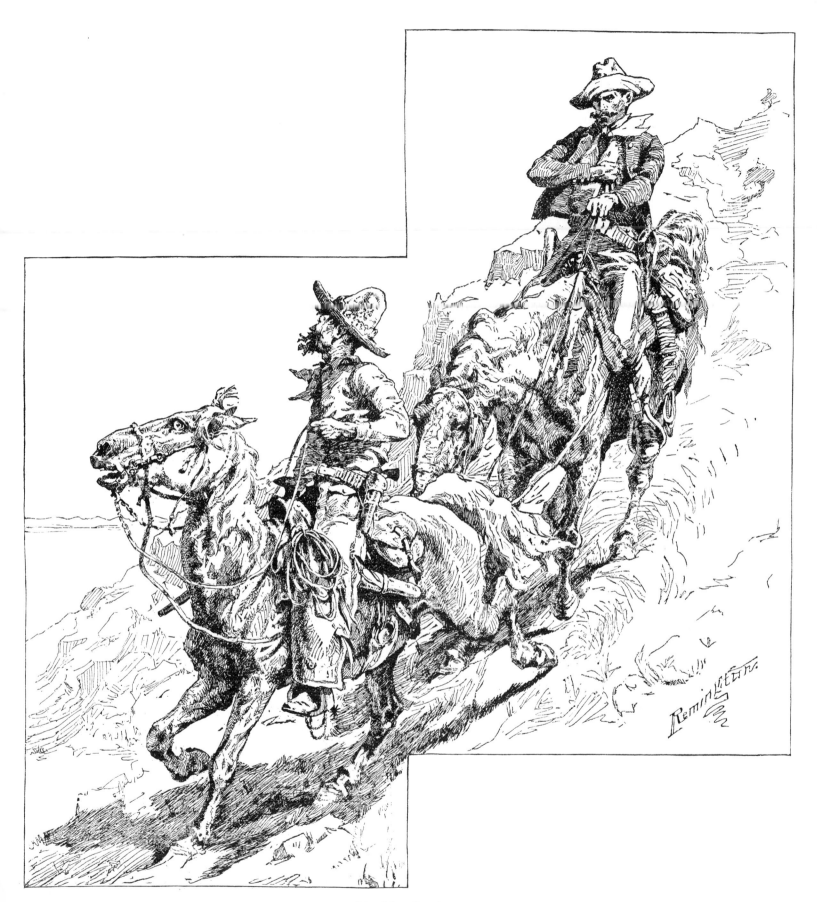

83 The Couriers

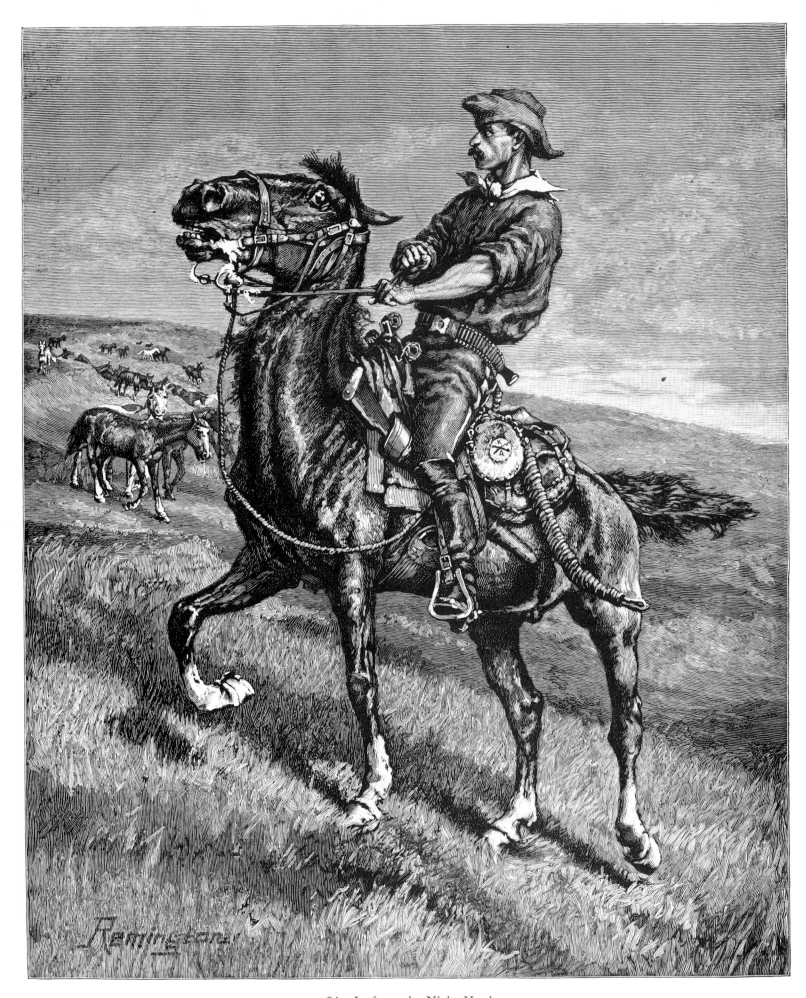

84 In from the Night Herd

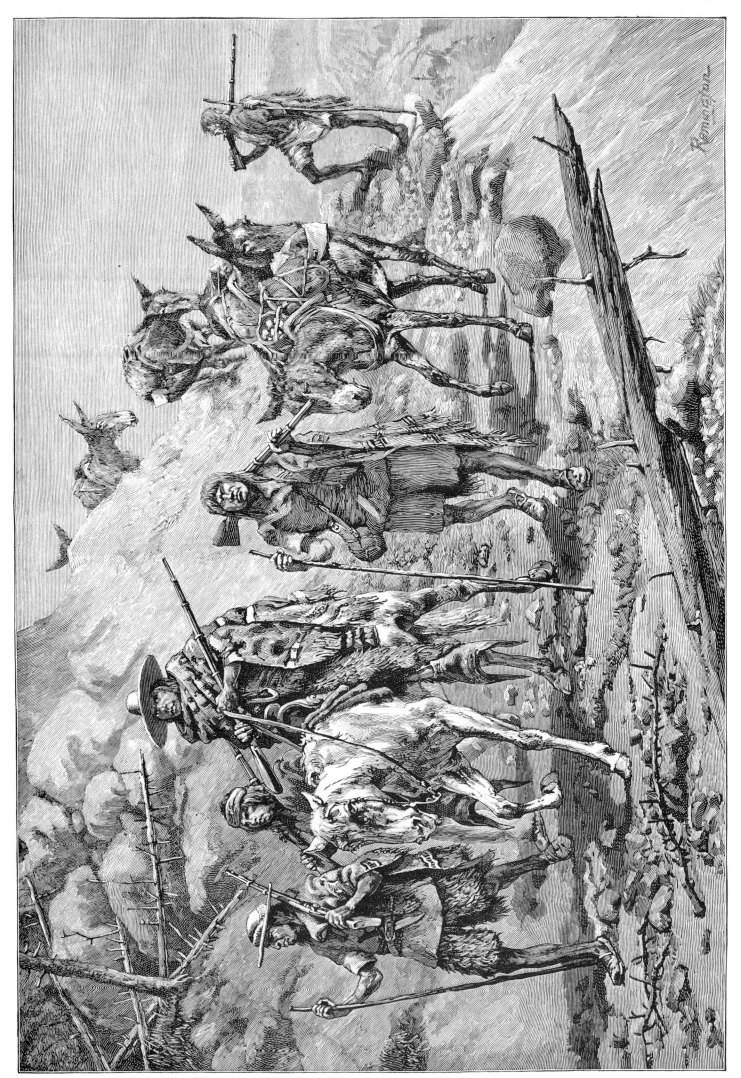

85 Pima Indians Convoying a Silver Train in Mexico

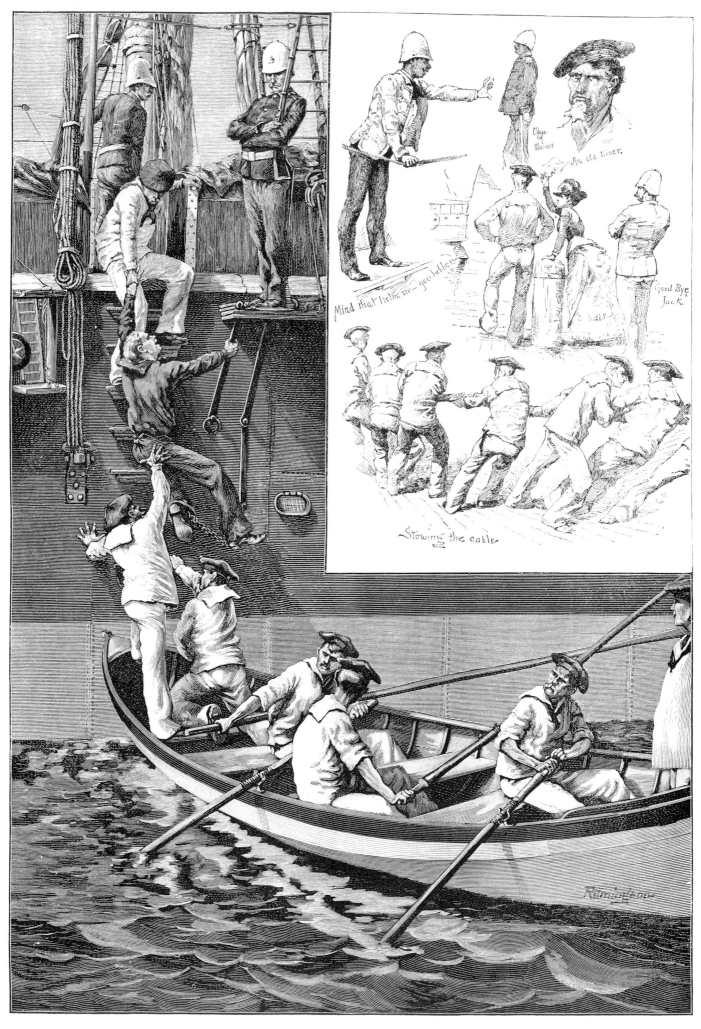

Mind that hatch sir—you lubber.

Officer of Marines

An old timer.

Good Bye Jack.

Stowing the cable.

86 Sketches on a Man-of-War under Sailing Orders—The Last on Board

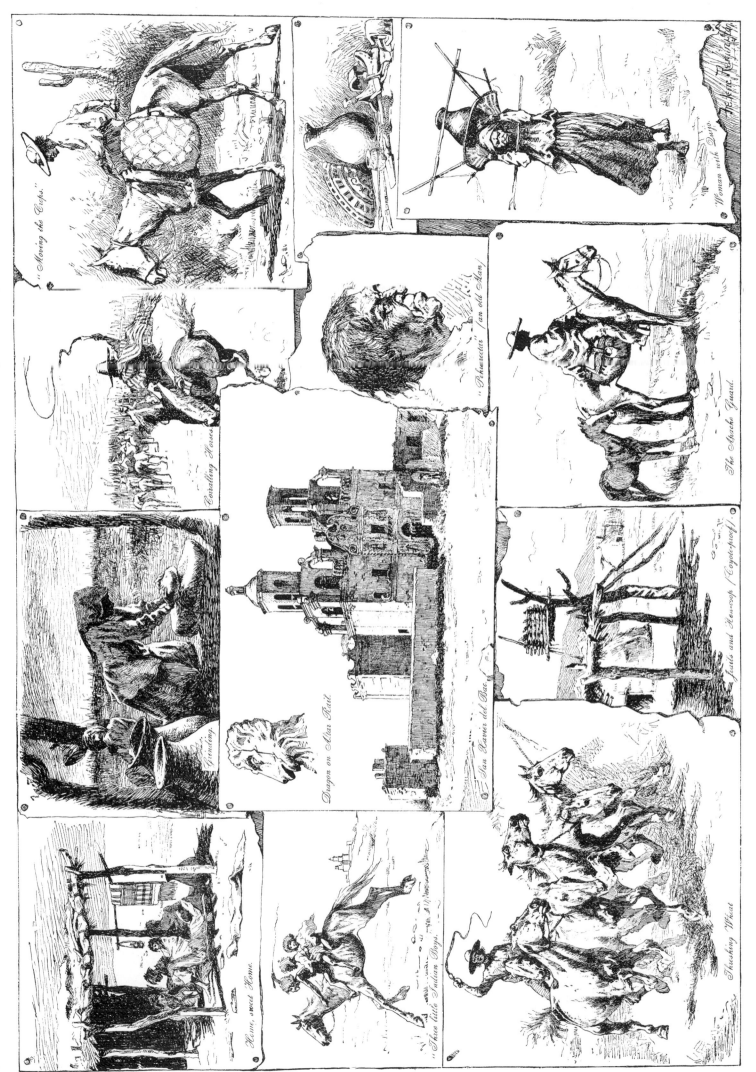

87 Sketches among the Papagos of San Xavier

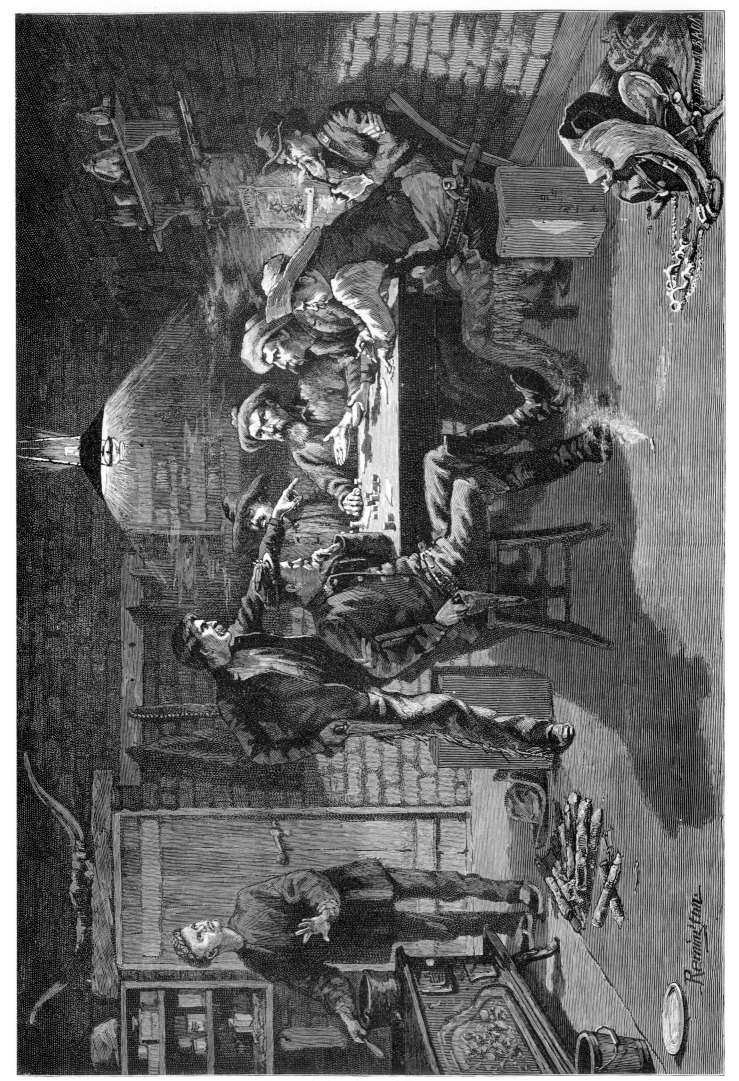

88 A Quarrel over Cards—A Sketch from a New Mexican Ranch

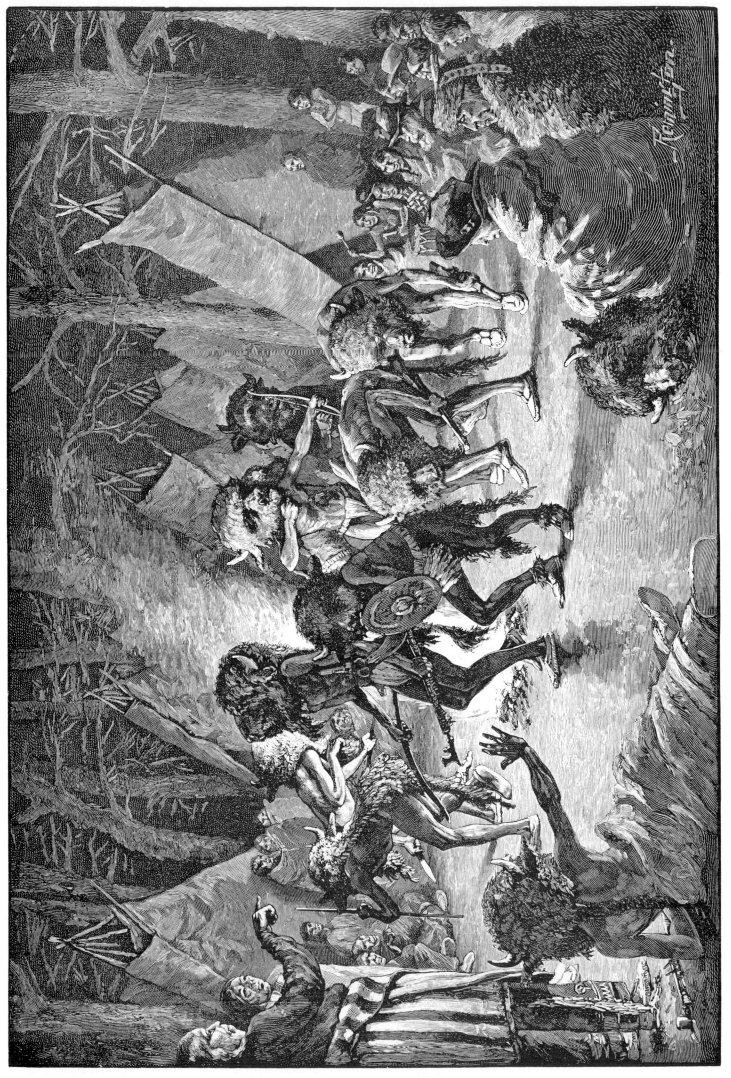

89 The Buffalo Dance

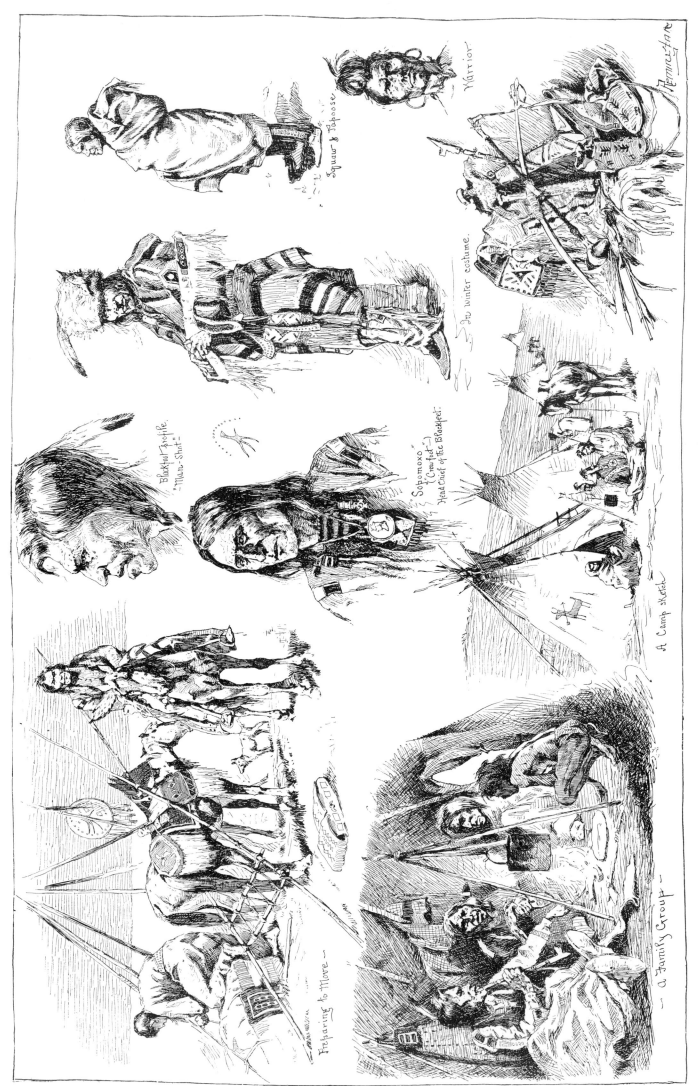

Squaw & Papoose.

Warrior

Remington

In winter costume.

Blackfoot Profile.
"Man-Shot"

Sopomoxo
("Crowfoot")
Head Chief of the Blackfeet.

A Camp Sketch

Preparing to Move

A Family Group

90 In the Lodges of the Blackfeet Indians

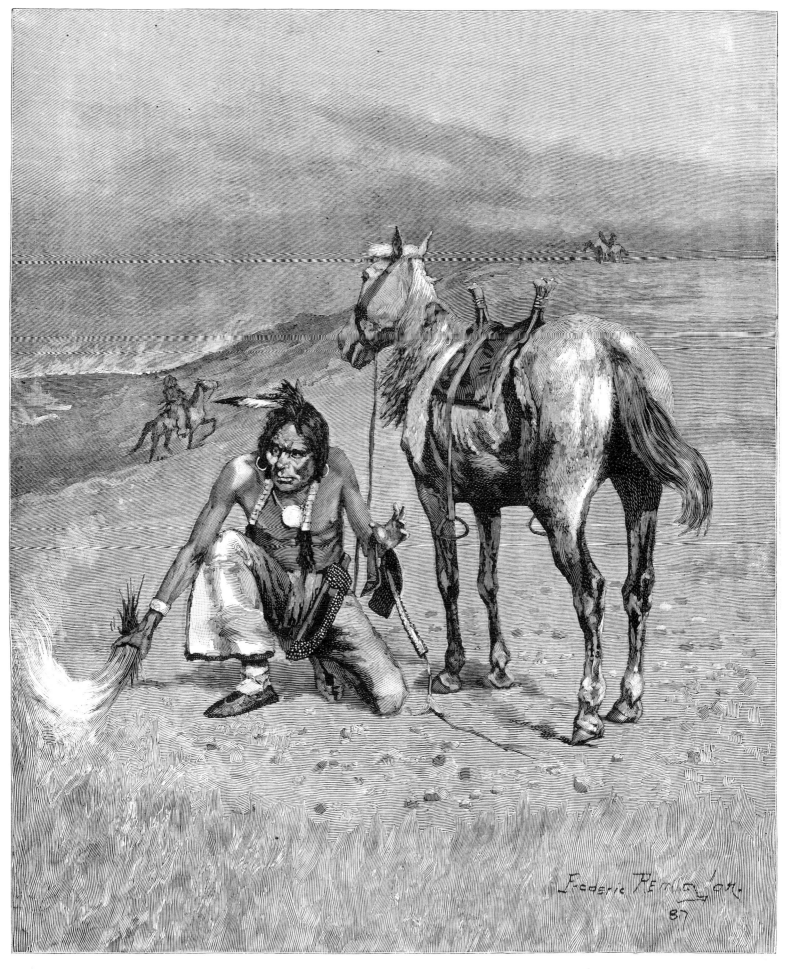

91 Burning the Range

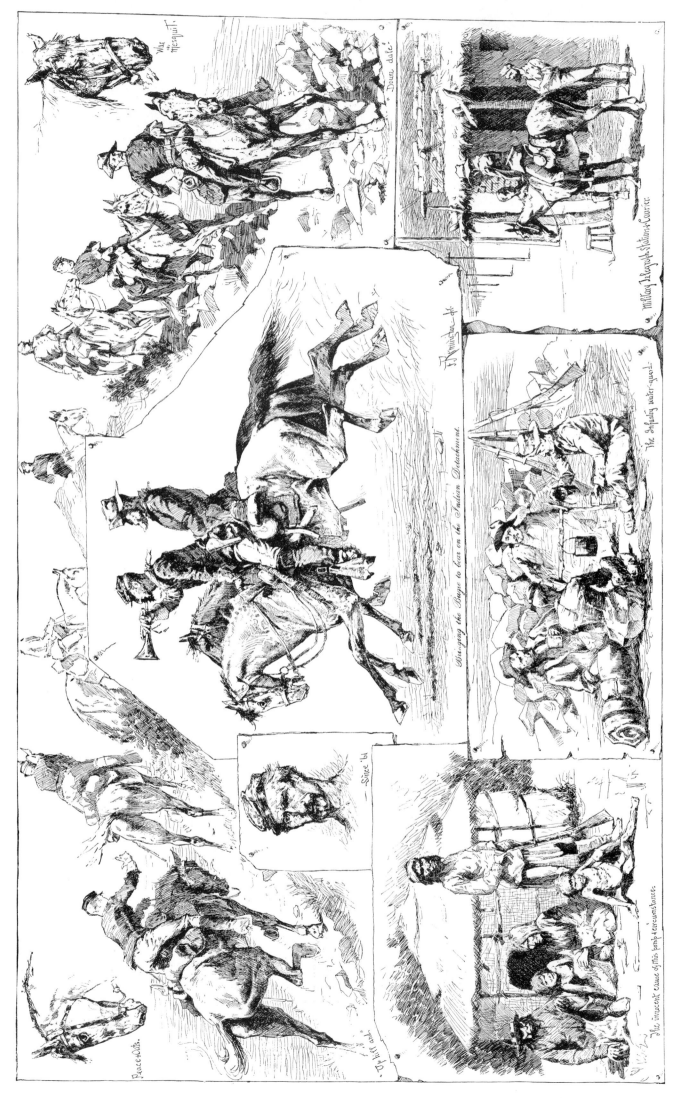

93 Crow Indians Firing into the Agency

94 Arrest of a Blackfeet Murderer

95 An Ox Train in the Mountains

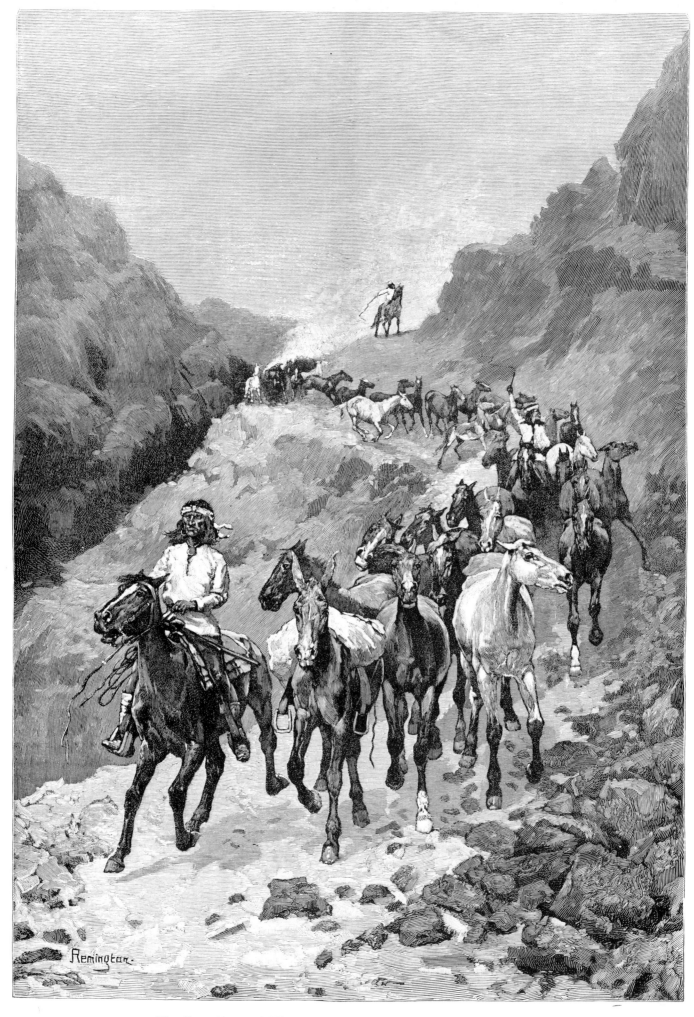

96 Geronimo and His Band Returning from a Raid into Mexico

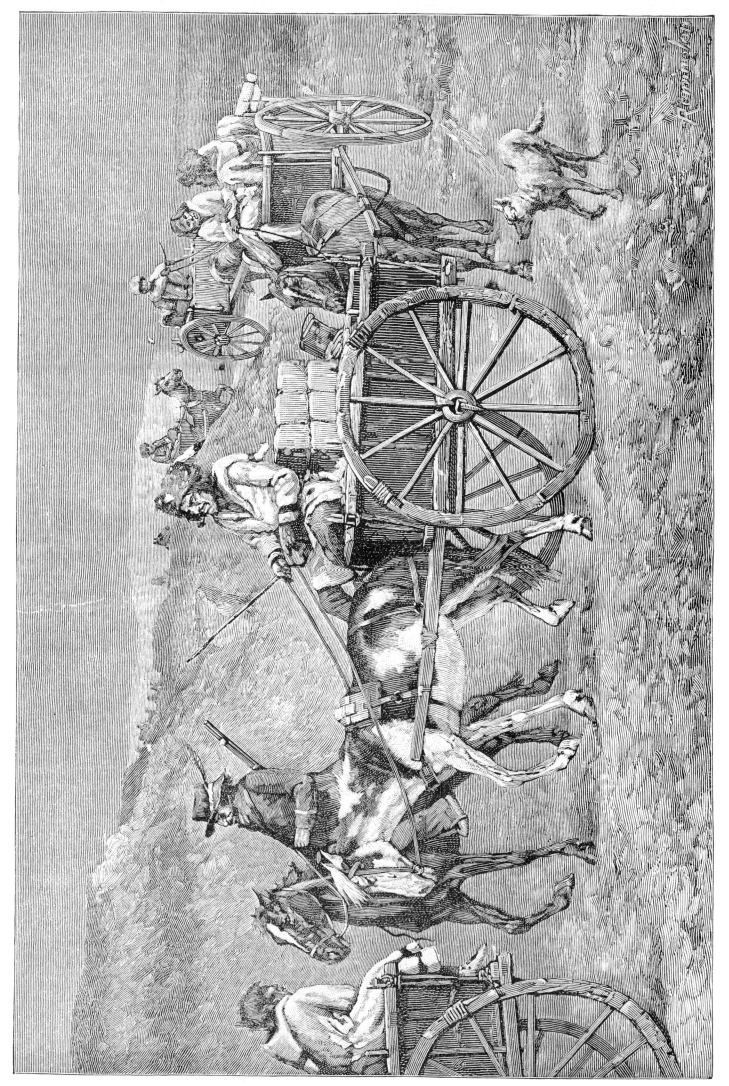

97 A Fur Train from the Far North

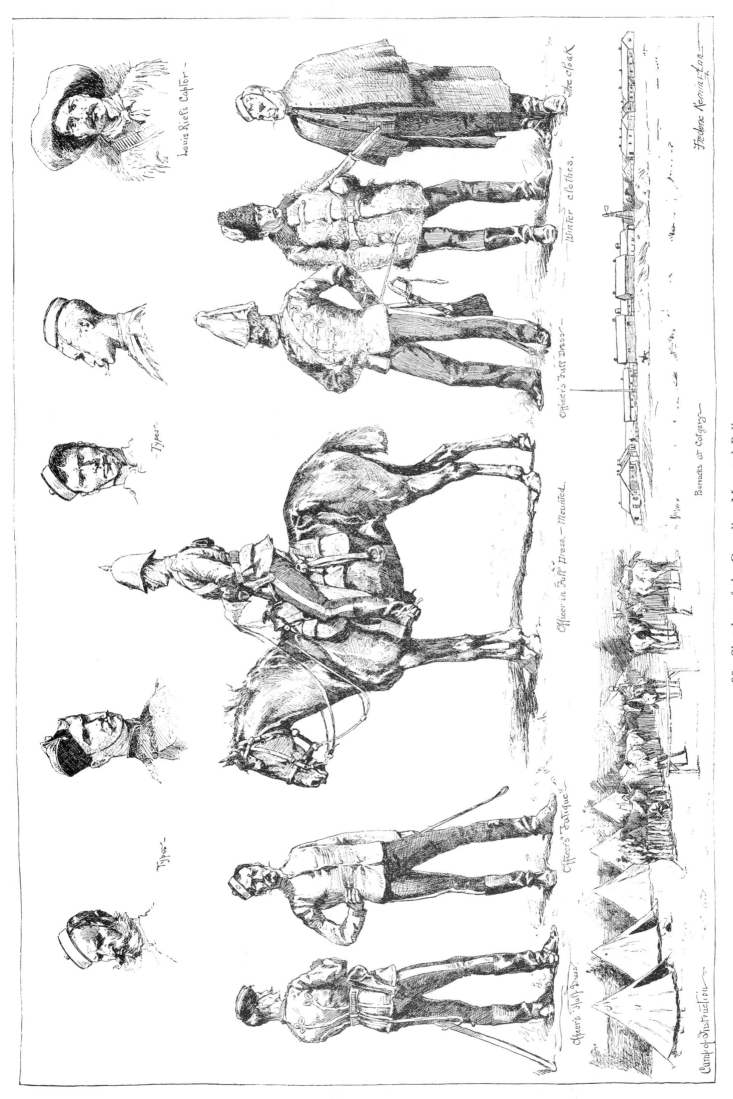

98 Sketches of the Canadian Mounted Police

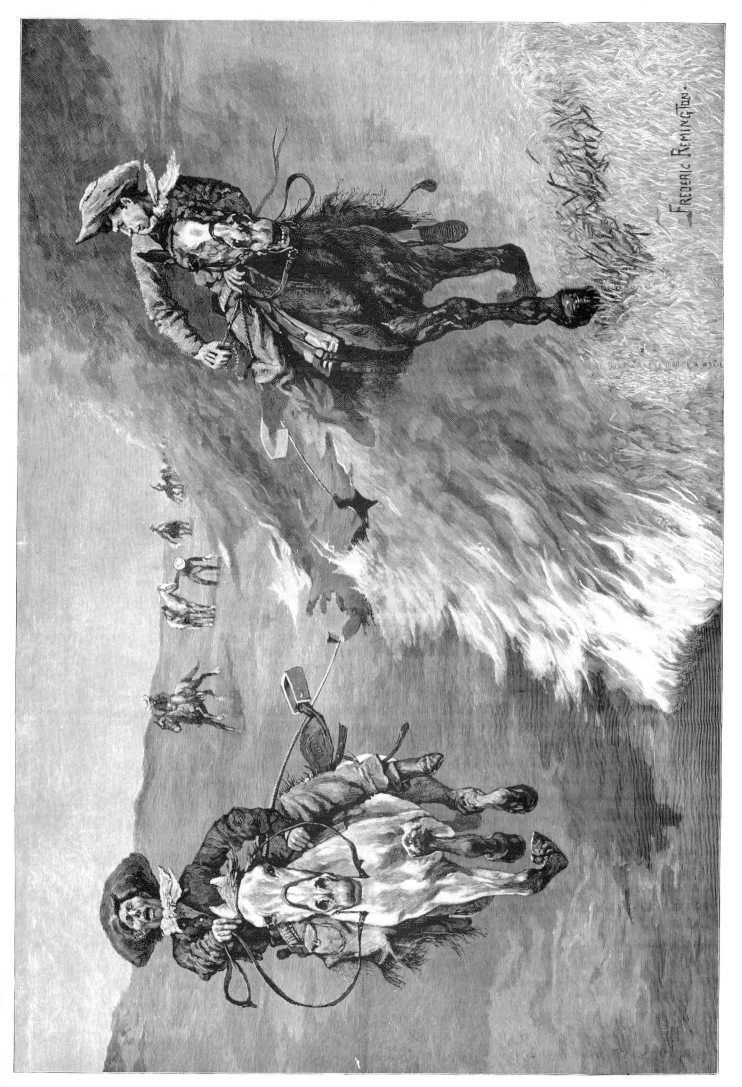

FREDERIC REMINGTON.

99 Dragging a Bull's Hide over a Prairie Fire in Northern Texas

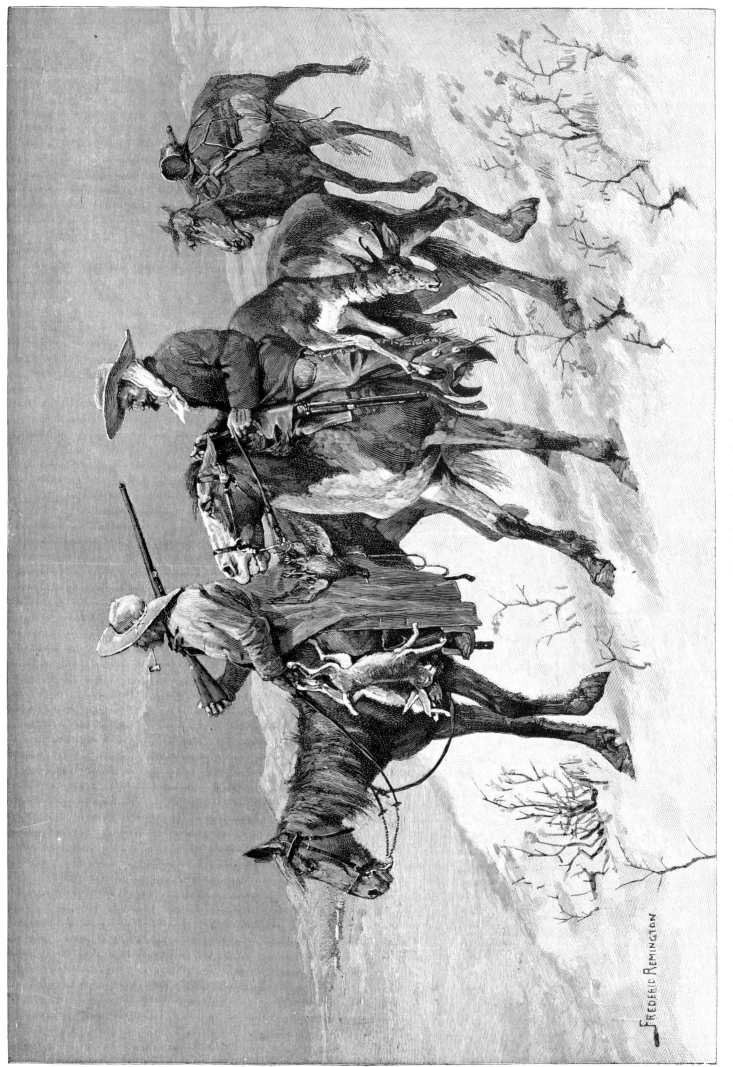

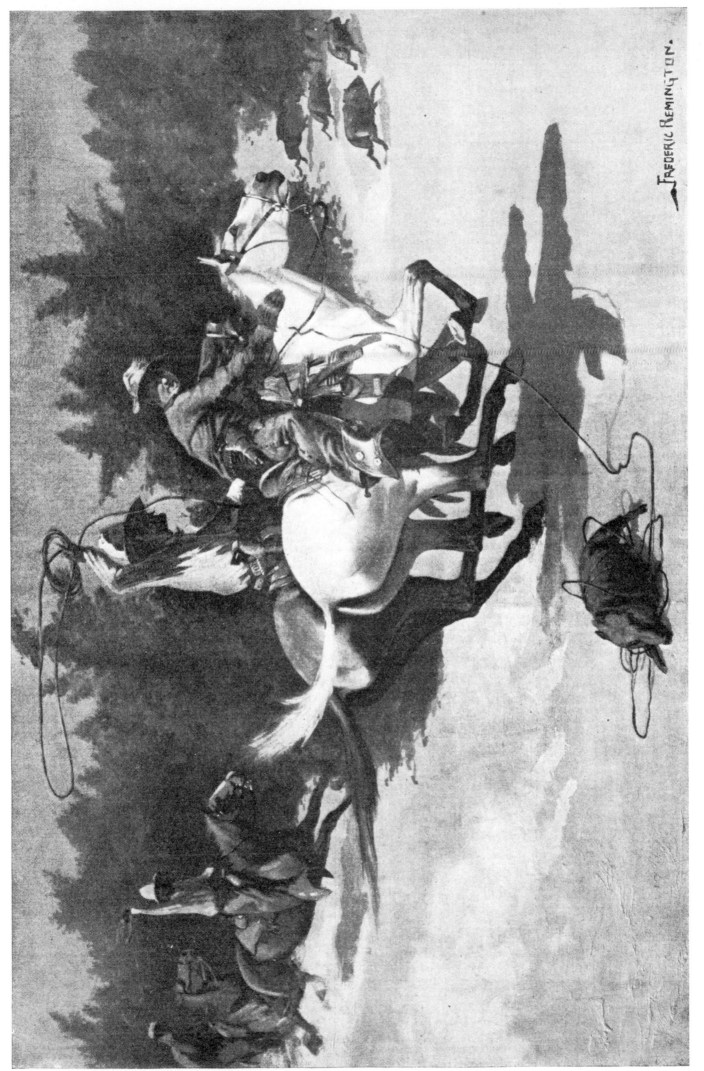

101 A Peccary Hunt in Northern Mexico

102 Bringing in a Deserter

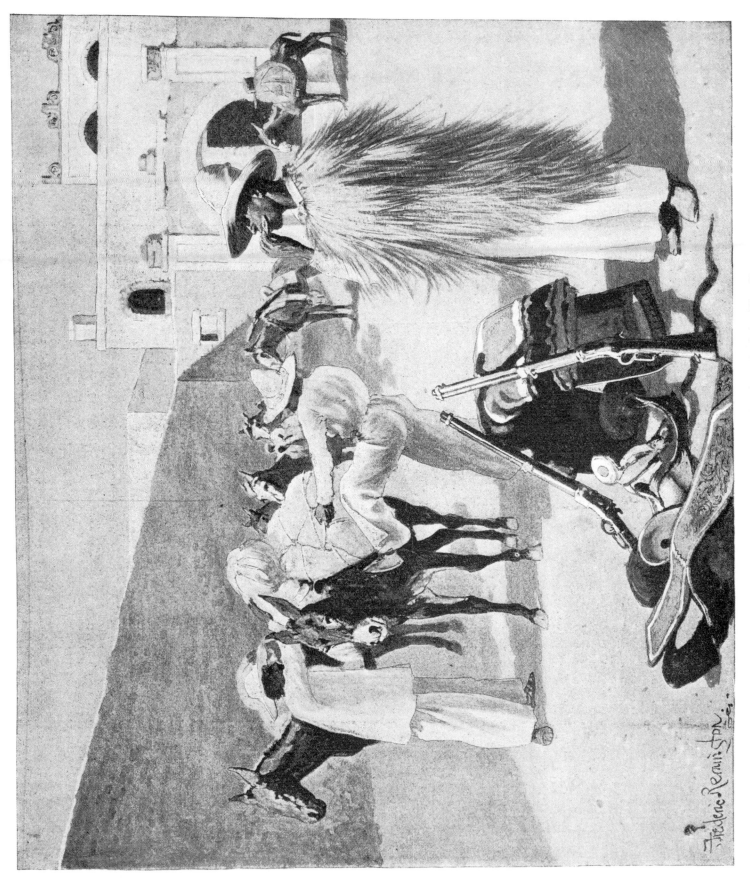

103 "We Packed Our Mules in the Corral of the Hotel"

104 The Fight in the Cañon

105 In the Cave of the Dead

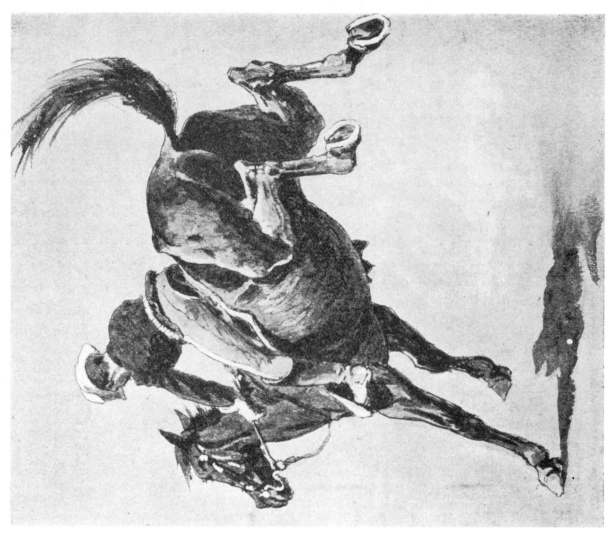

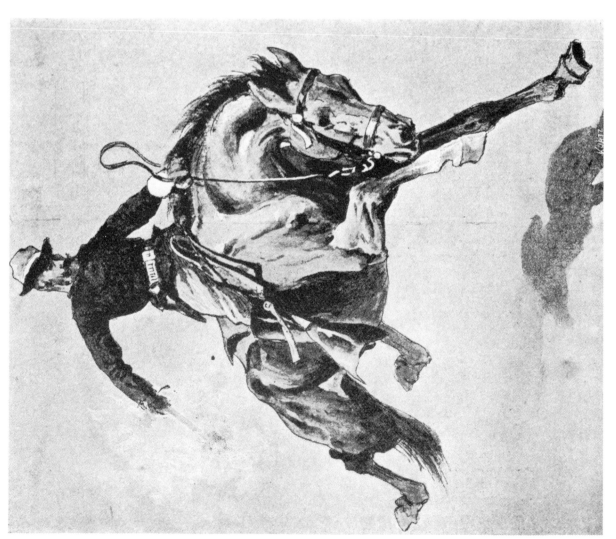

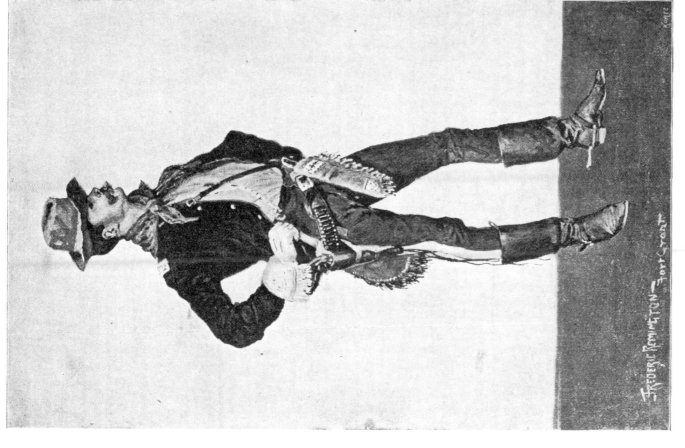

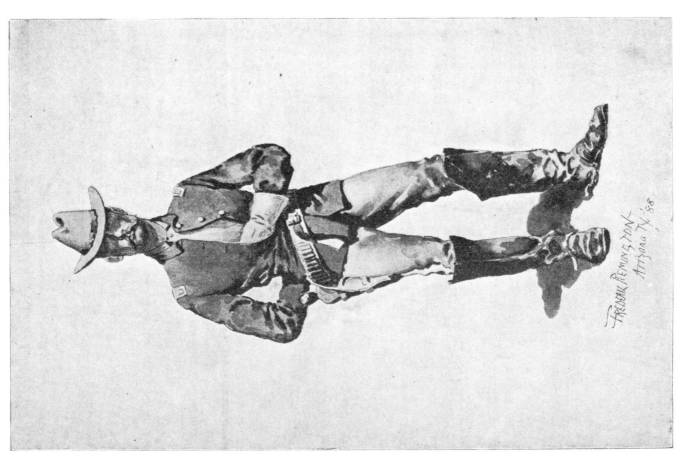

107 Two Distinguished Cavalry Officers: Lieutenant James M. Watson, Tenth Cavalry, and Lieutenant Powhatan H. Clarke, Tenth Cavalry

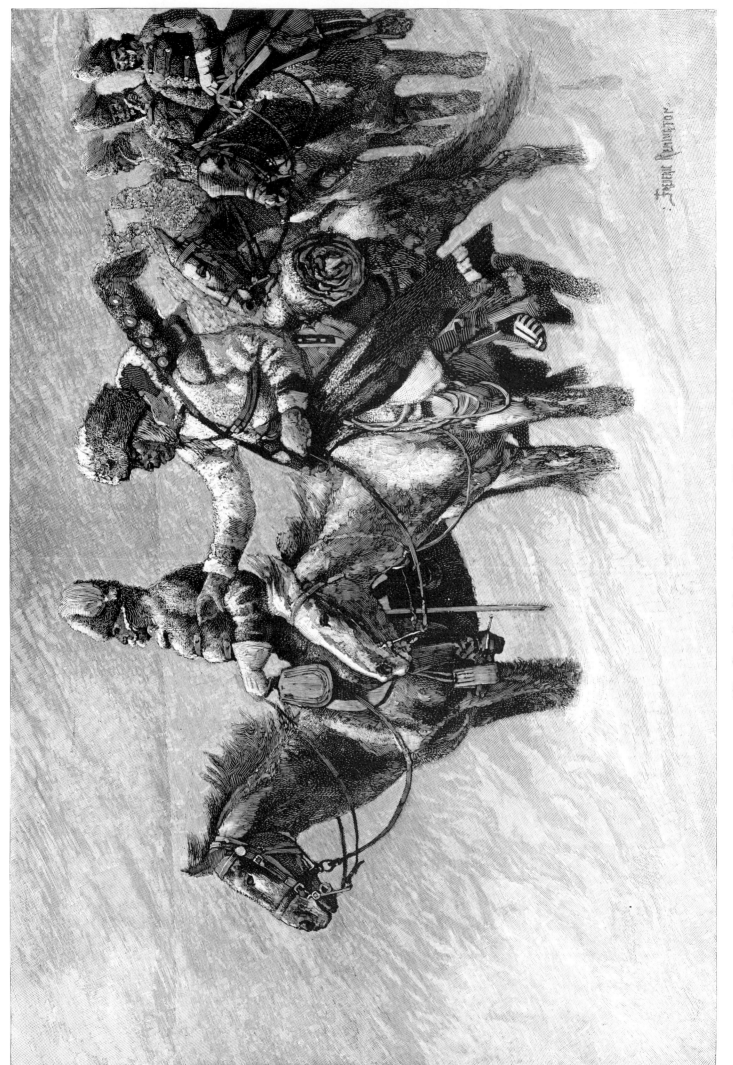

108 Canadian Mounted Police on a Winter Expedition

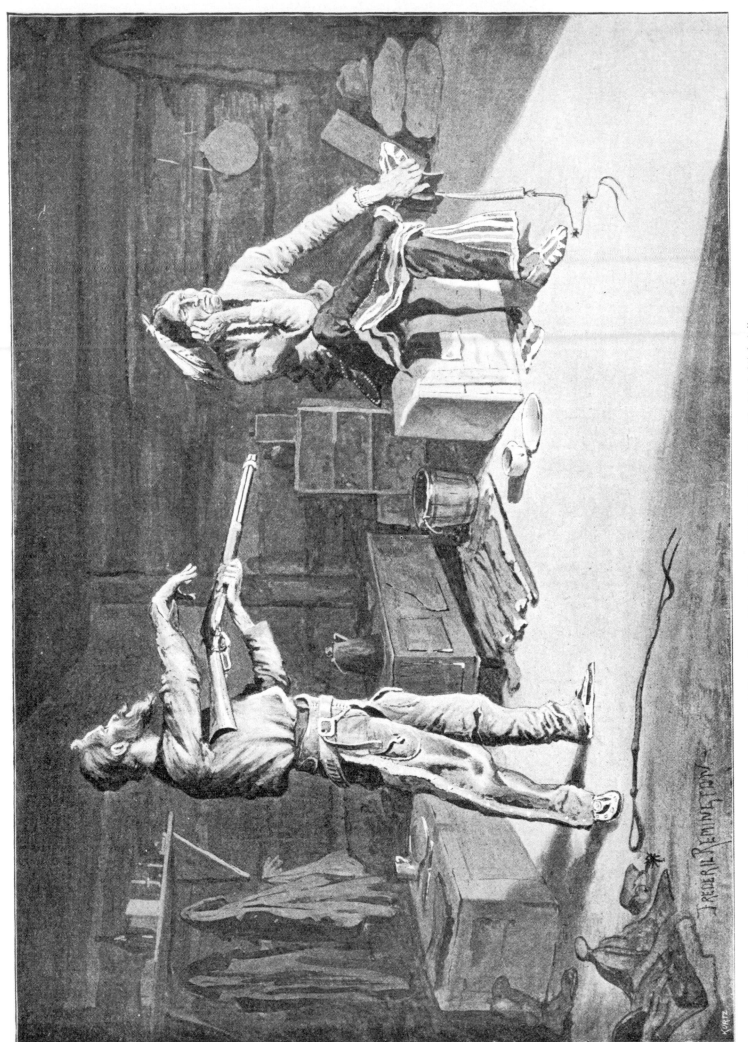

109 "You Know This Thing, Chief?' The Indian Nodded Slightly"

Frederic Remington

110 Mr. Jones's Adventure

111 Questionable Companionship

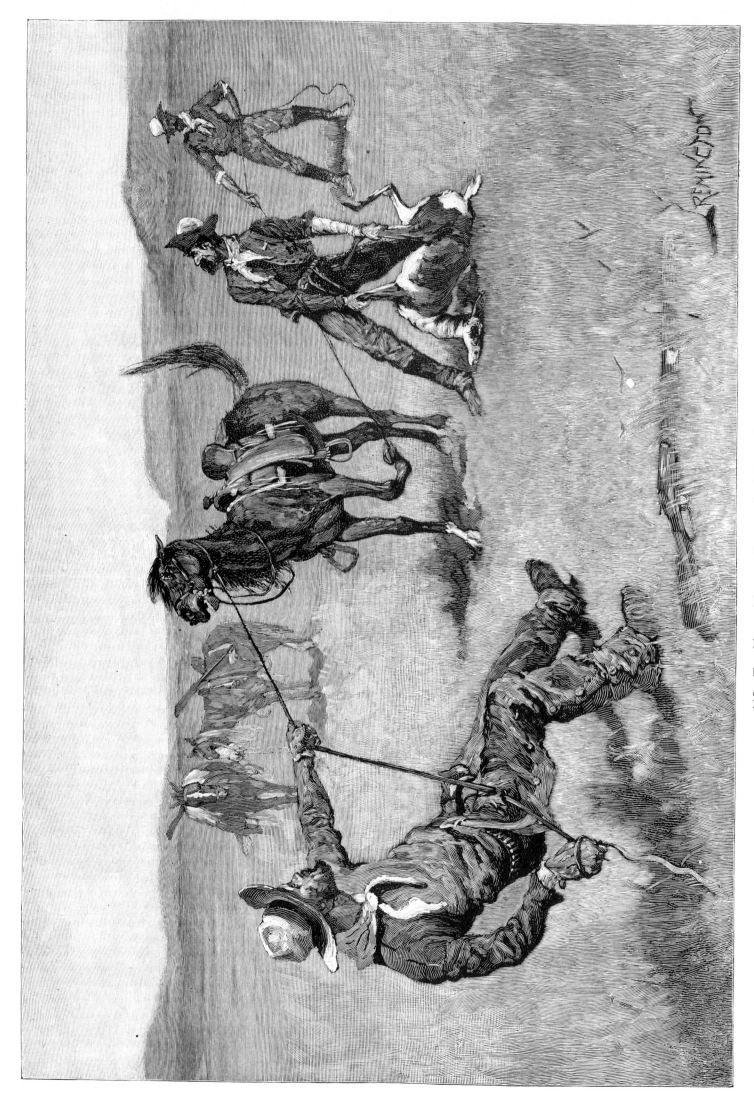

112 Teaching a Mustang Pony to Pack Dead Game

113 The Mexican Major

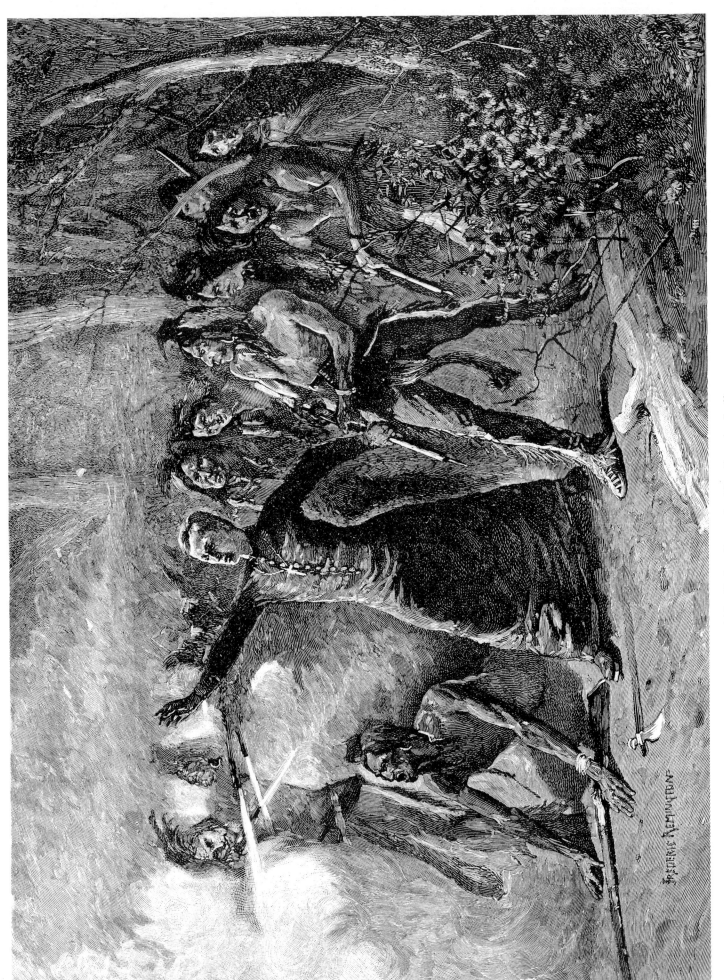

114 Father Lacombe Heading the Indians

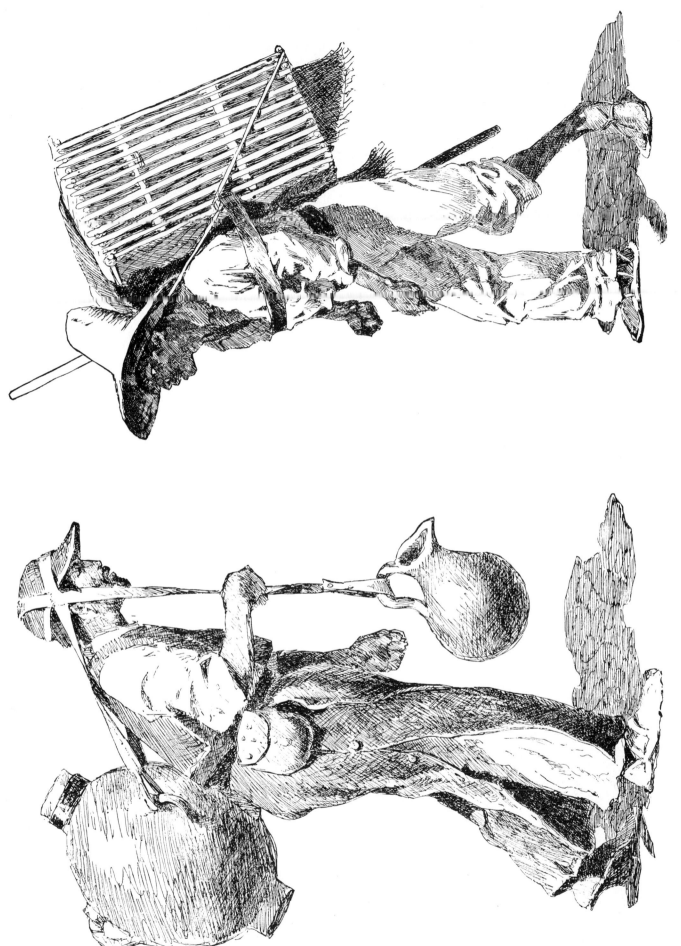

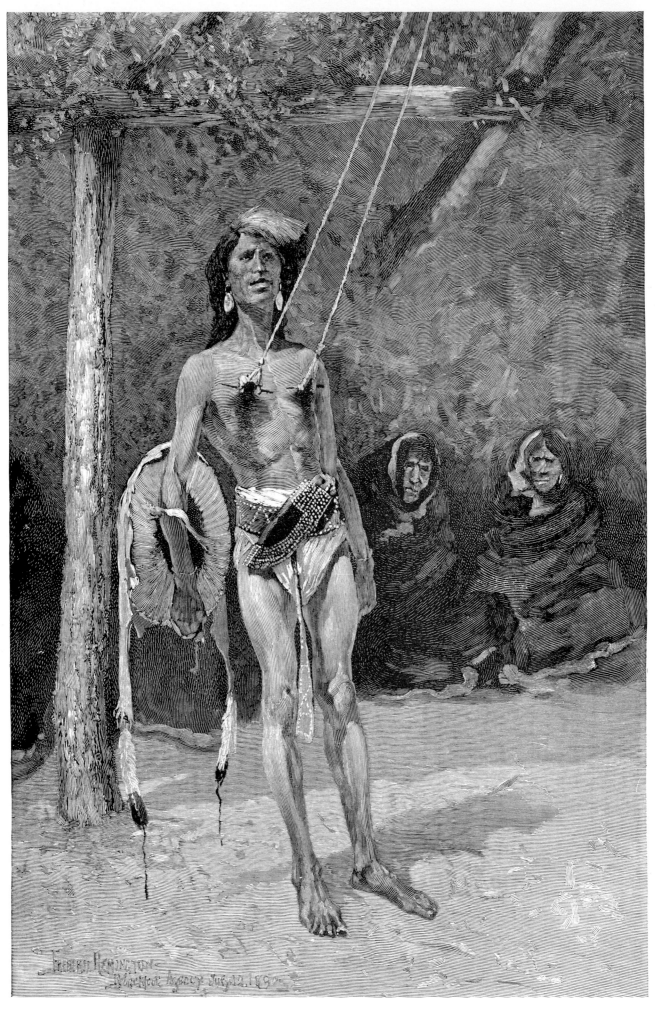

116 The Ordeal in the Sun Dance among the Blackfeet Indians

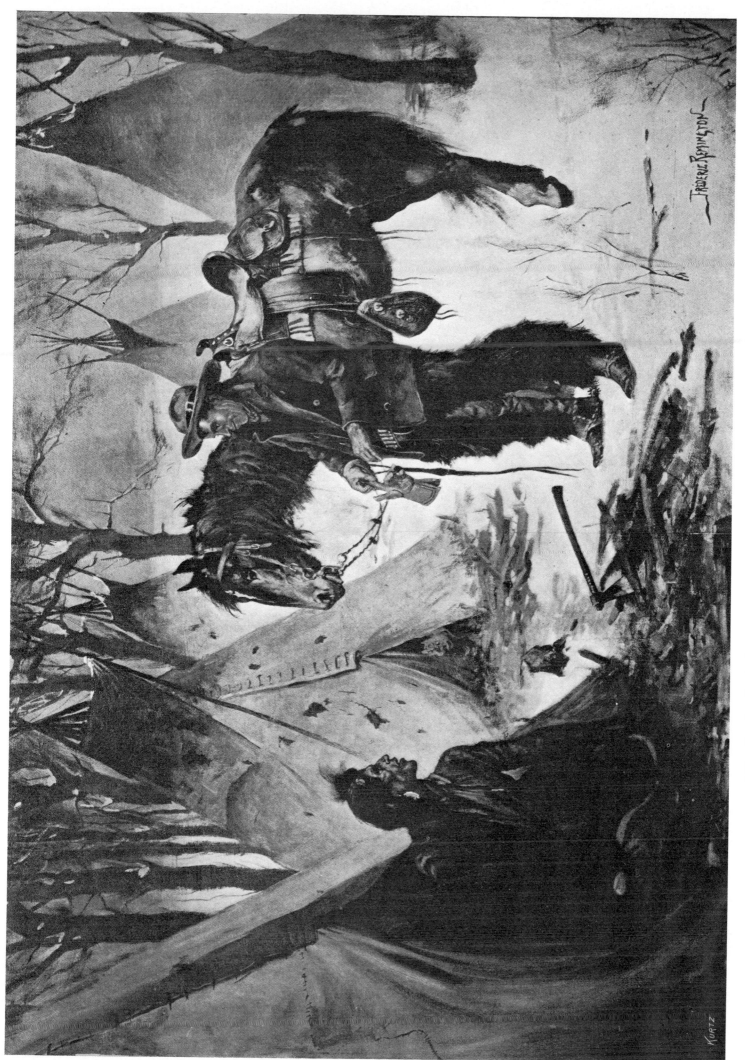

117 On the Cattle Range—"What's the Show for a Christmas Dinner, Chief?"

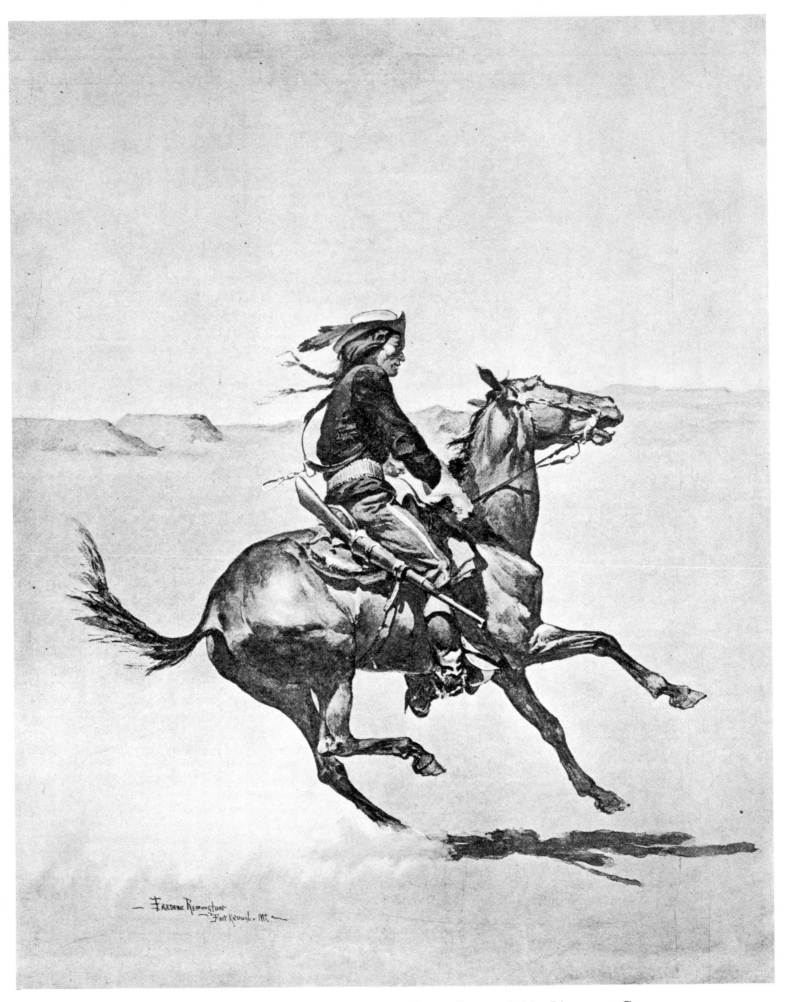

118 One of the Fort Keogh Cheyenne Scout Corps, Commanded by Lieutenant Casey

119 The Last Stand

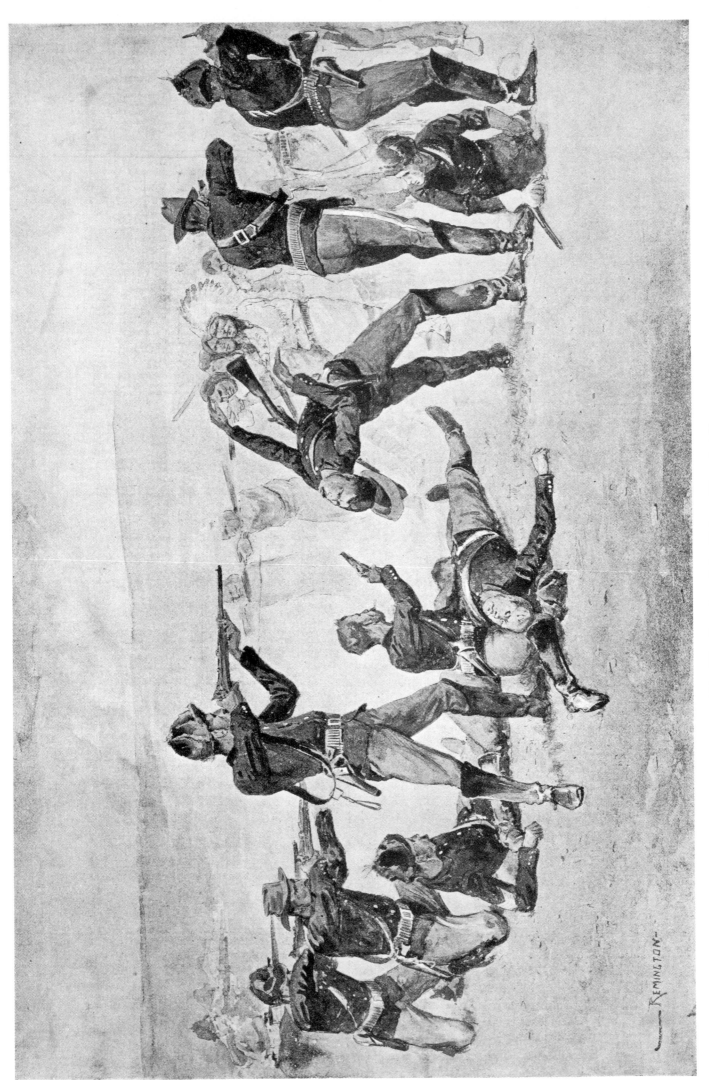

120 The Opening of the Fight at Wounded Knee

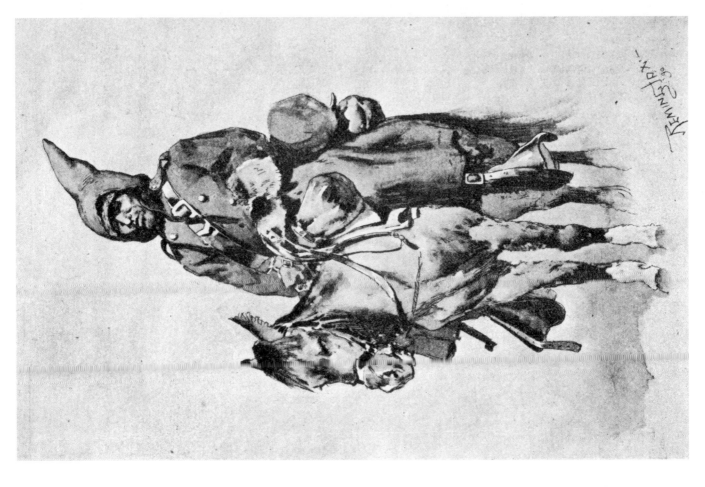

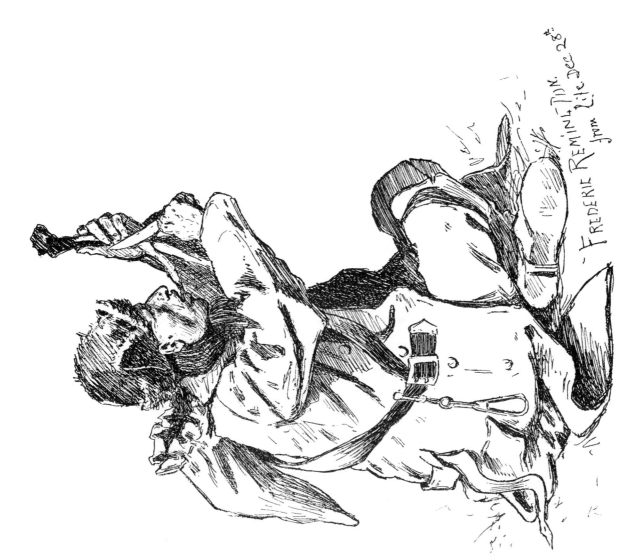

121 Cheyenne Scout Eating a Beef Rib; A Cheyenne Scout in Winter Rig

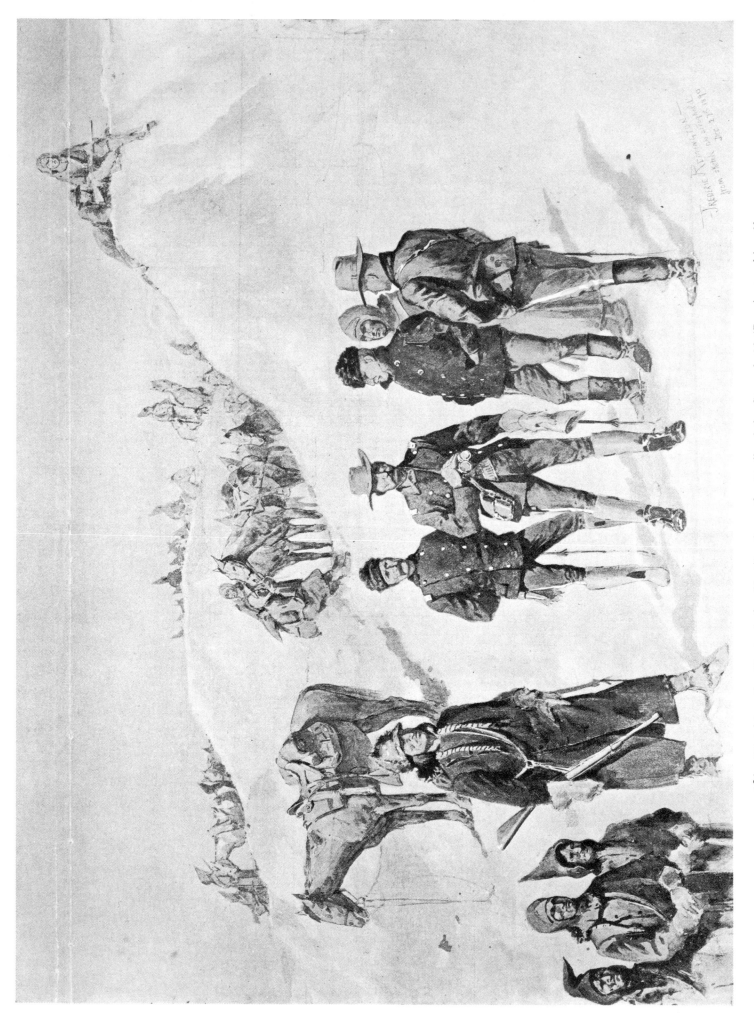

122　Watching the Dust of the Hostiles from the Bluffs of the Stronghold (Remington himself is the third from the right, wearing a fur cap)

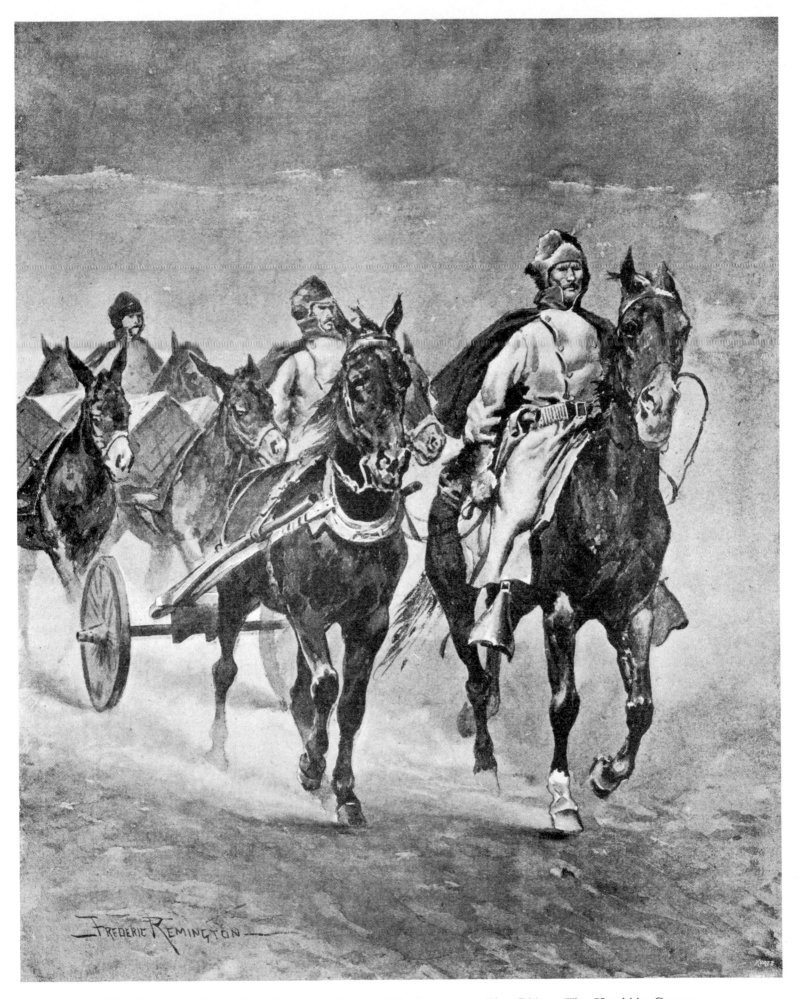

123 The Sioux War—Final Review of General Miles's Army at Pine Ridge—The Hotchkiss Cannon

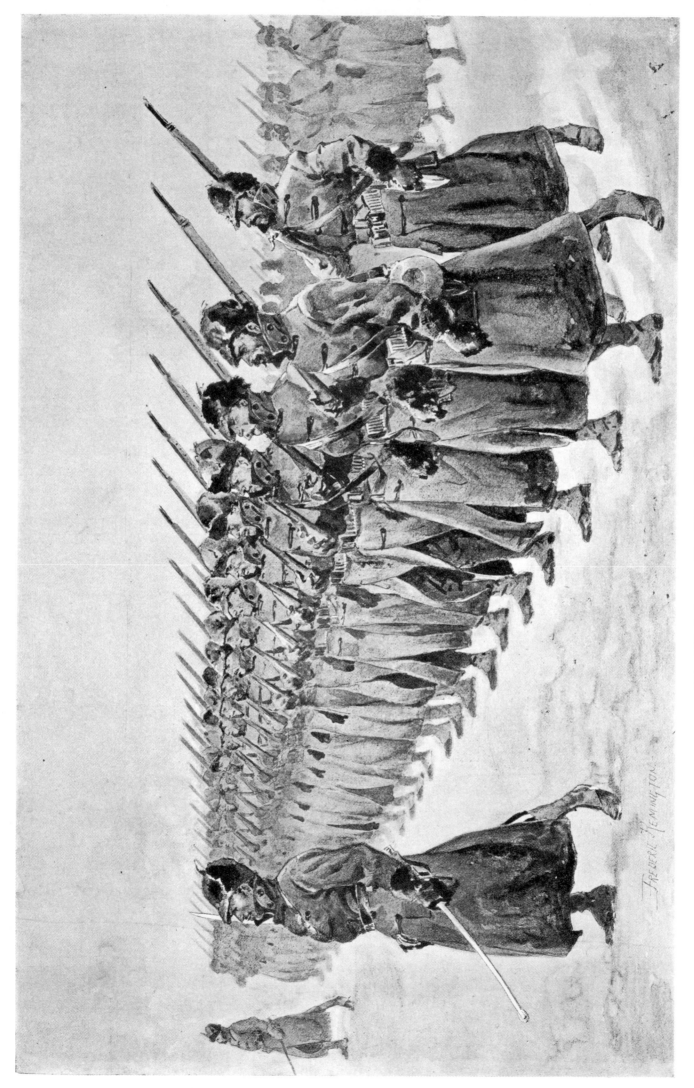

124 Miles's Army at Pine Ridge—The Infantry

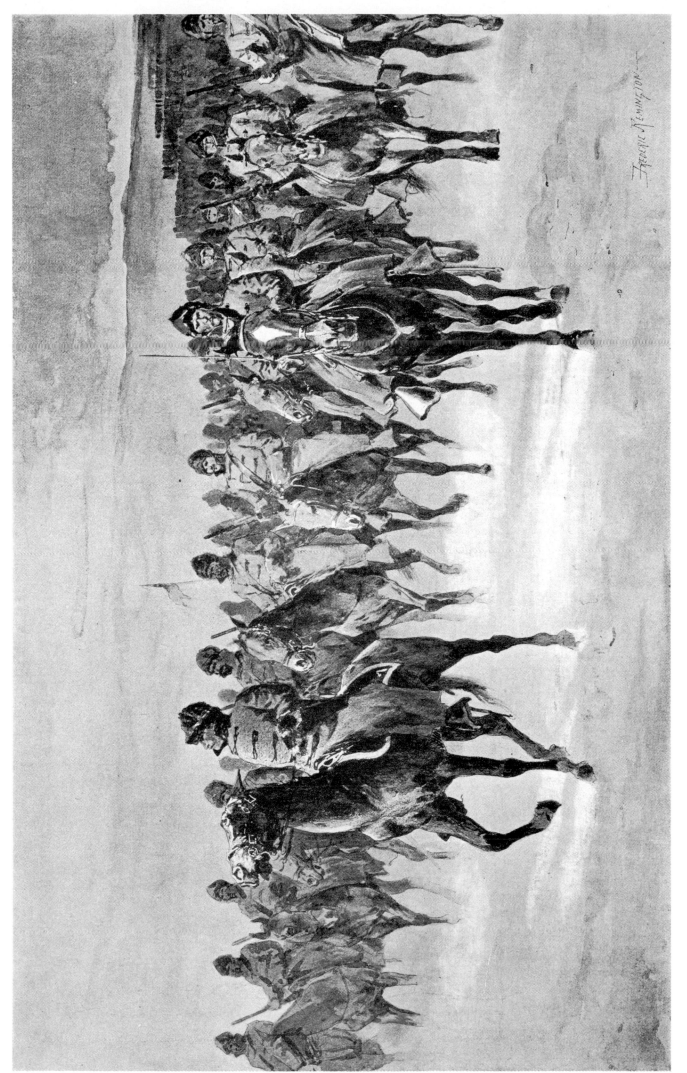

125 Miles's Army at Pine Ridge—The Cavalry

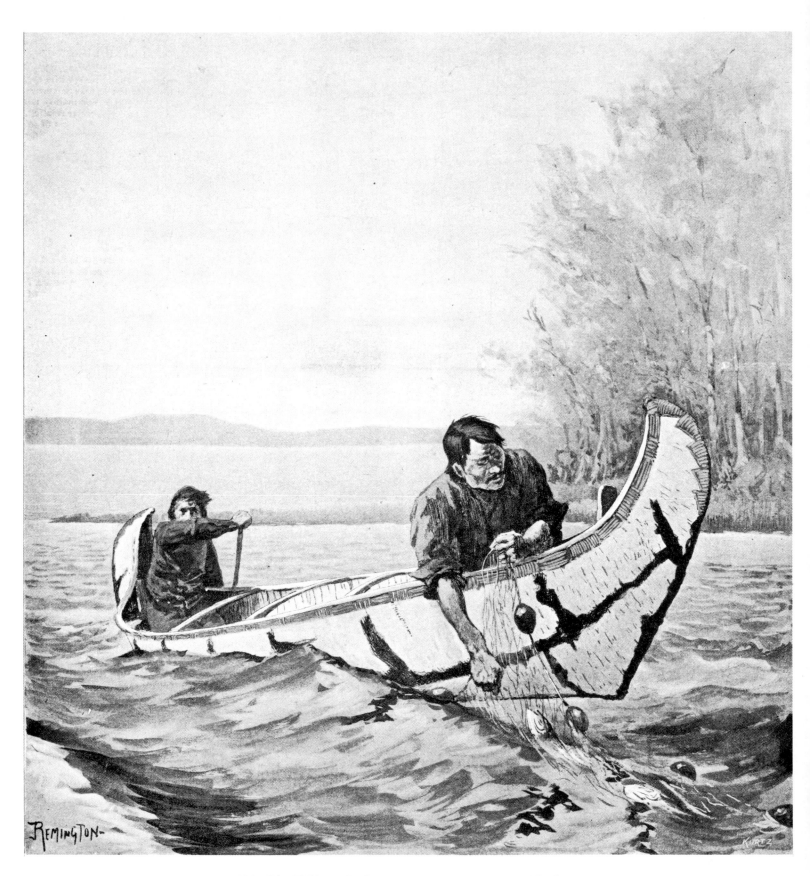

126 Big Fishing—Indians Hauling Nets on Lake Nepigon

127 American Tourists in Mexico

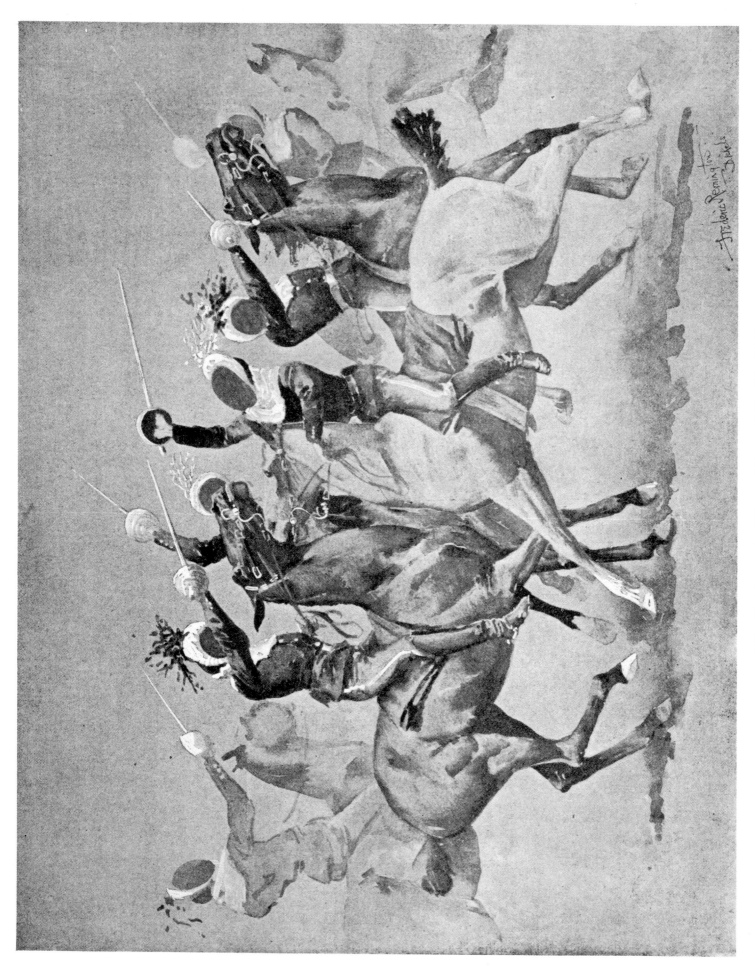

128 Sketches at the "Circus of Troop 'A'"—The Melée

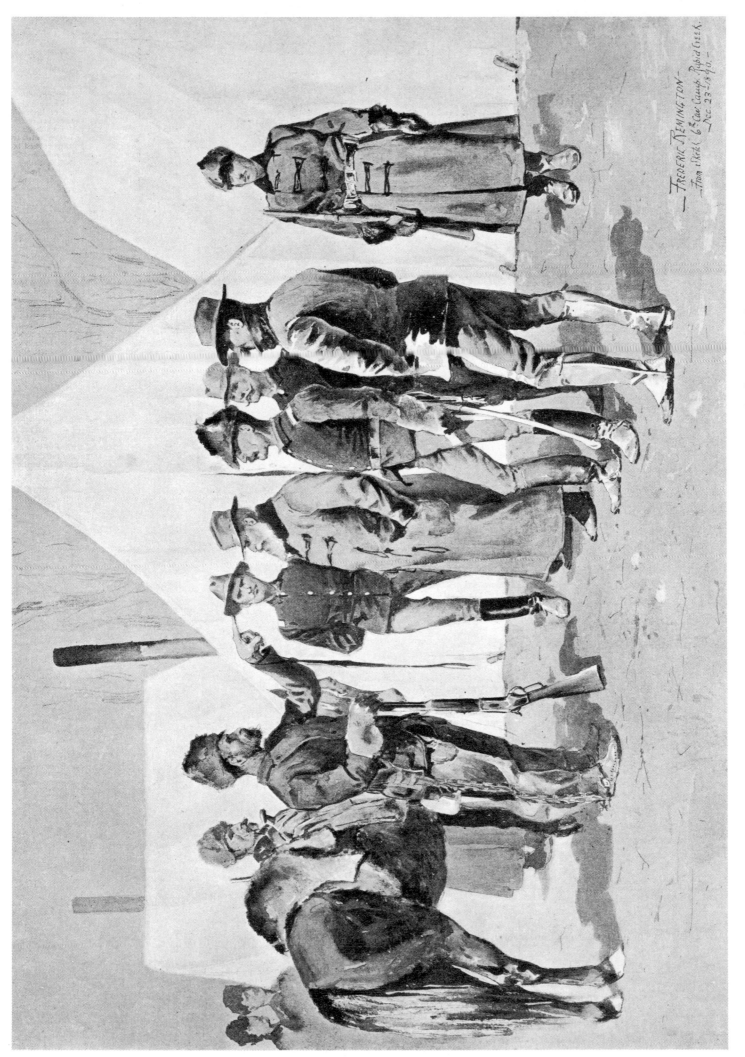

— FREDERIC REMINGTON —
From sketch 6 Cav. Camp, Rapid Creek.
Dec 23–1890. –

129 At the Mouth of Rapid Creek—General Carr Receiving the Report of a Scout

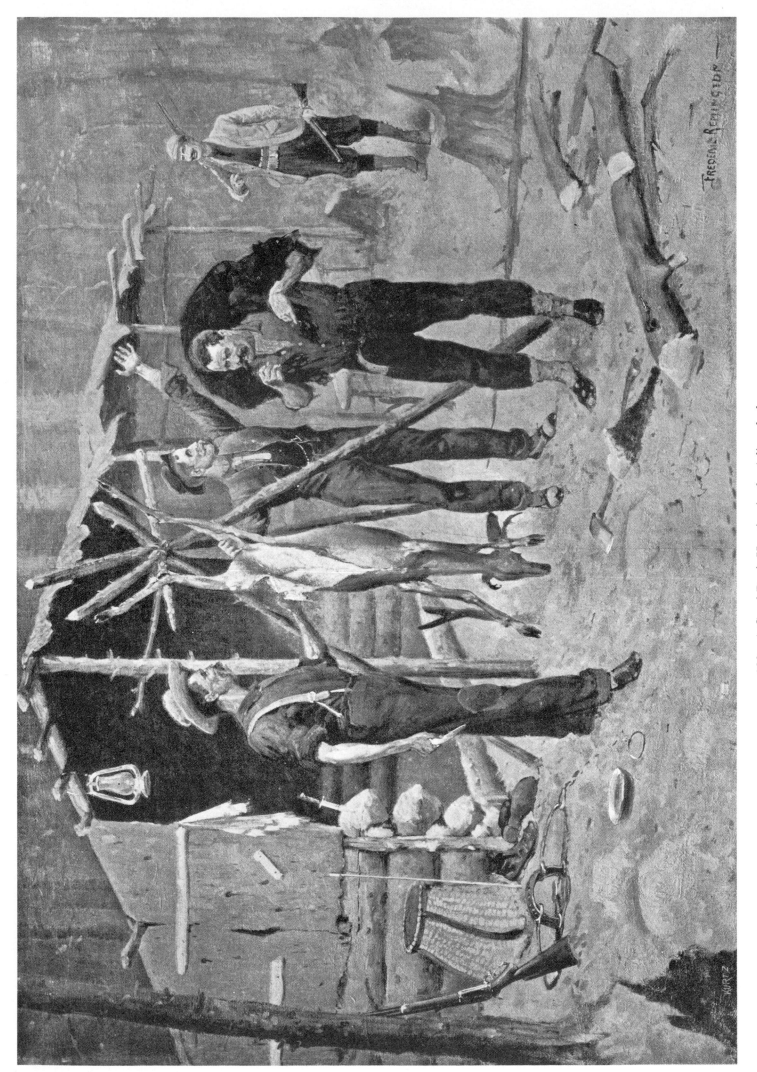

130 A Good Day's Hunting in the Adirondacks

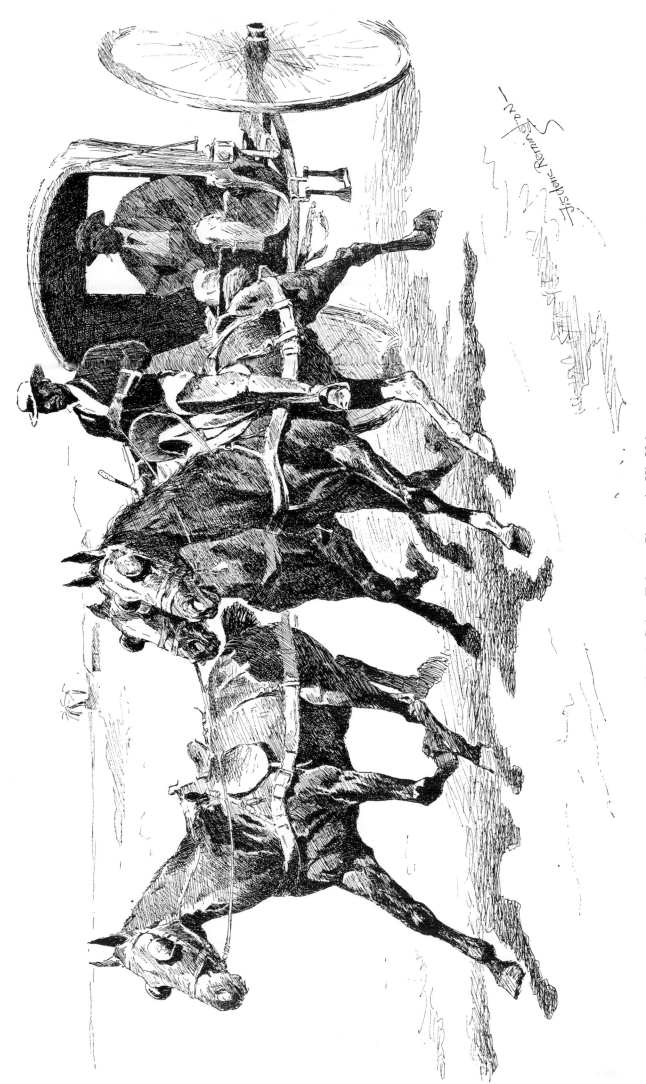

131 A Cuban Tobacco-Planter in His Volante

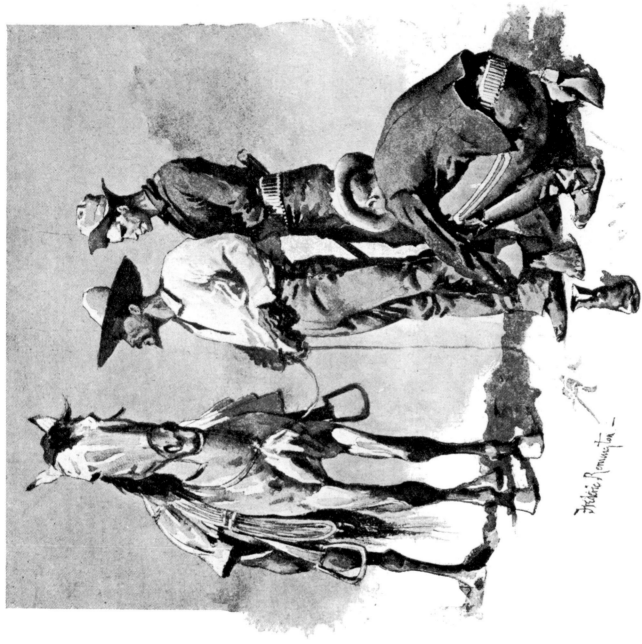

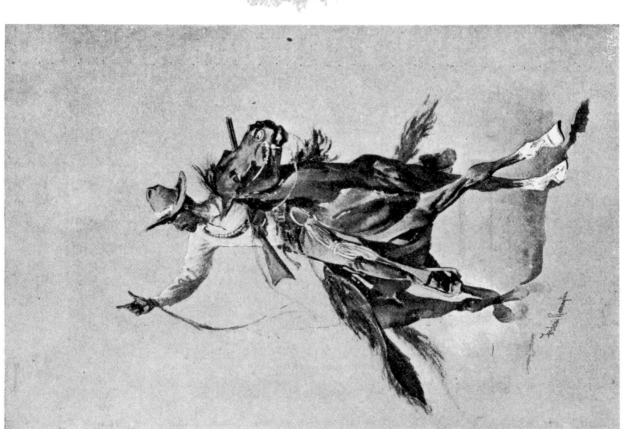

132 The Mexican Guide; Third Cavalry Troopers—Searching a Suspected Revolutionist

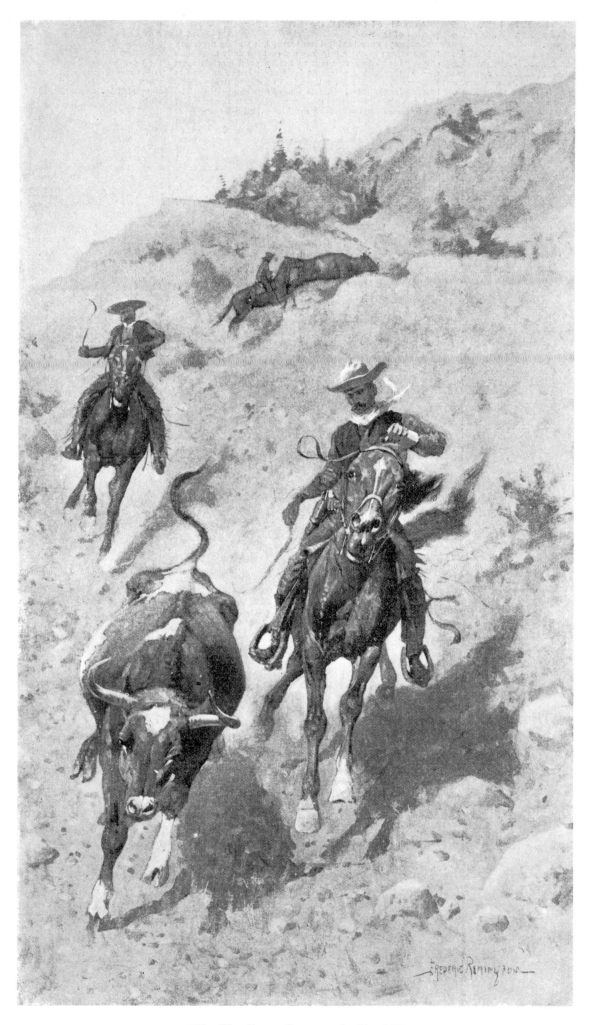

133 Heading a Steer on the Foothills

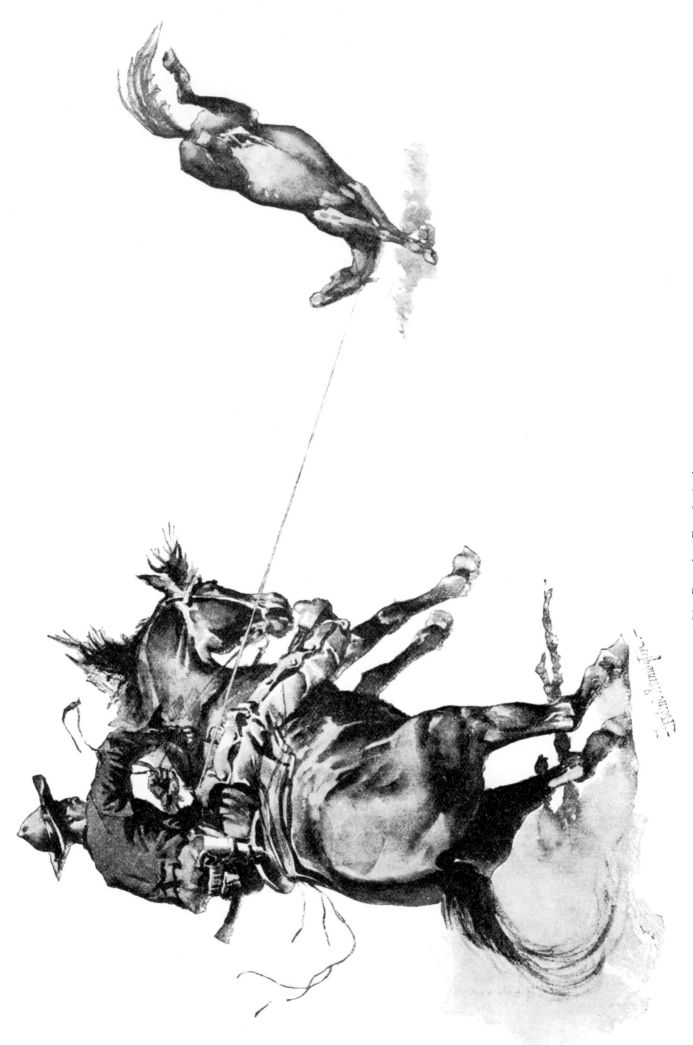

134 Reaction Equals Action

Frederic Remington

135 The Beef Issue at Anadarko

Frederic Remington — West Point Riding Hall —

136 Five-Foot Hurdle Bareback

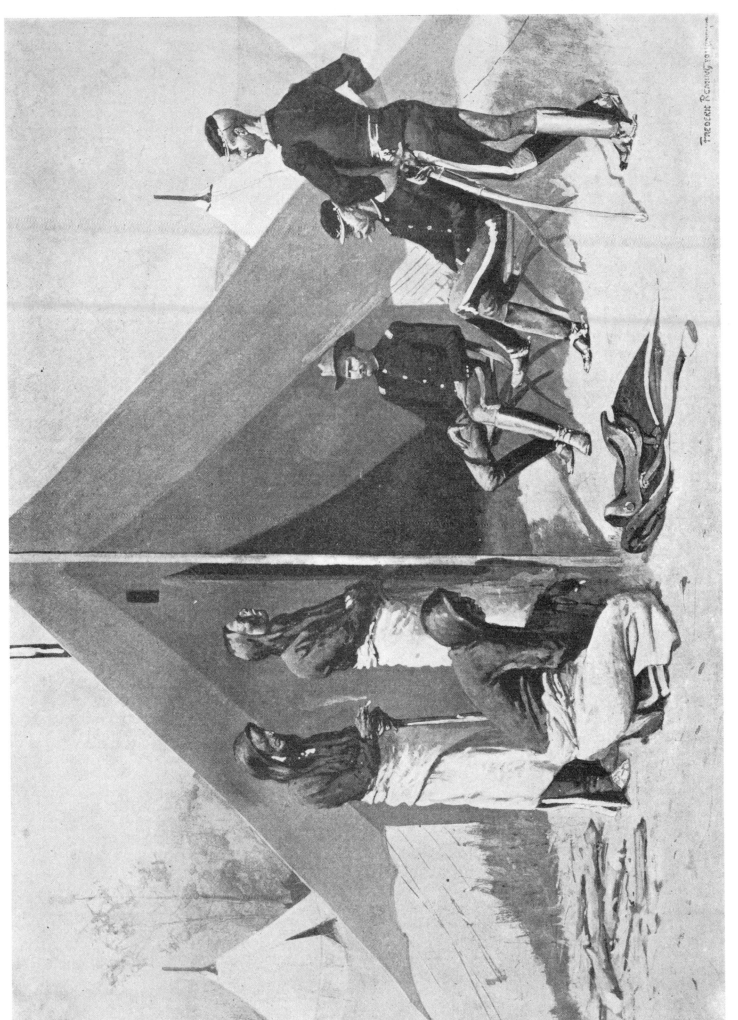

137 An Appeal for Justice

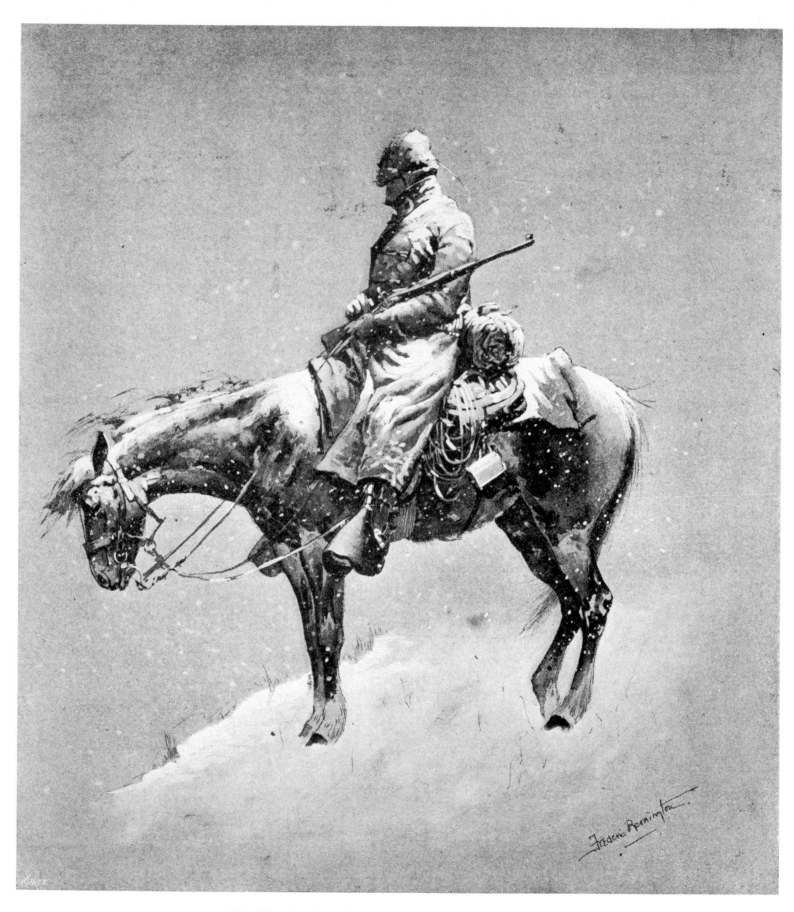

138 The American Tommy Atkins in a Montana Blizzard

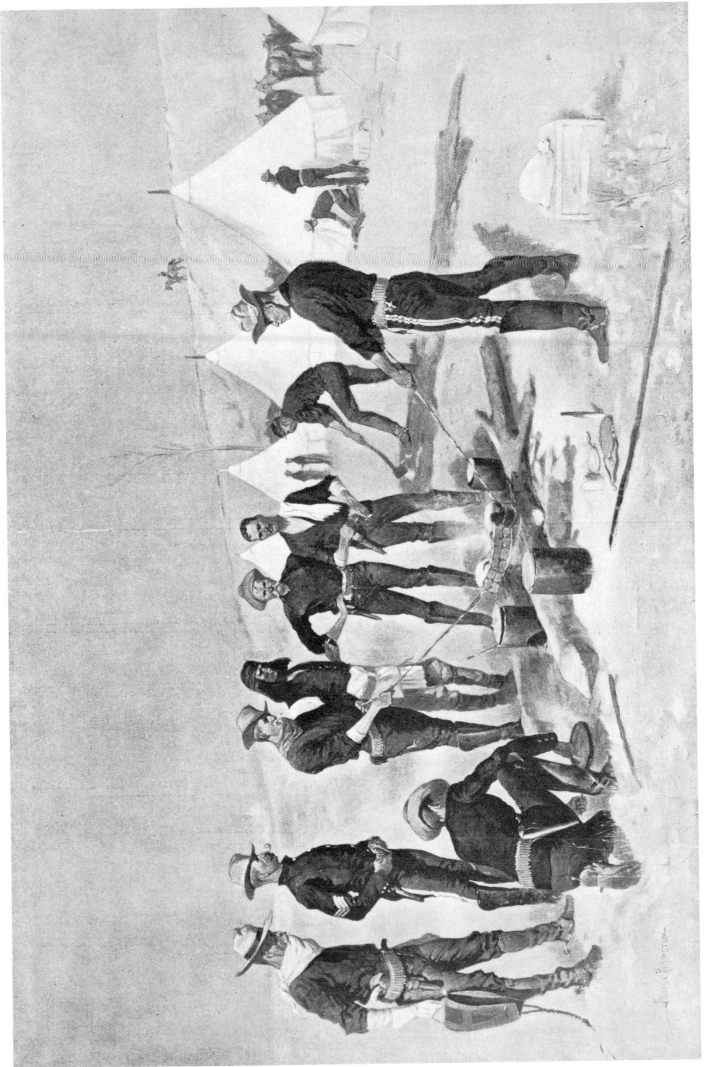

139 Roasting the Christmas Beef in a Cavalry Camp

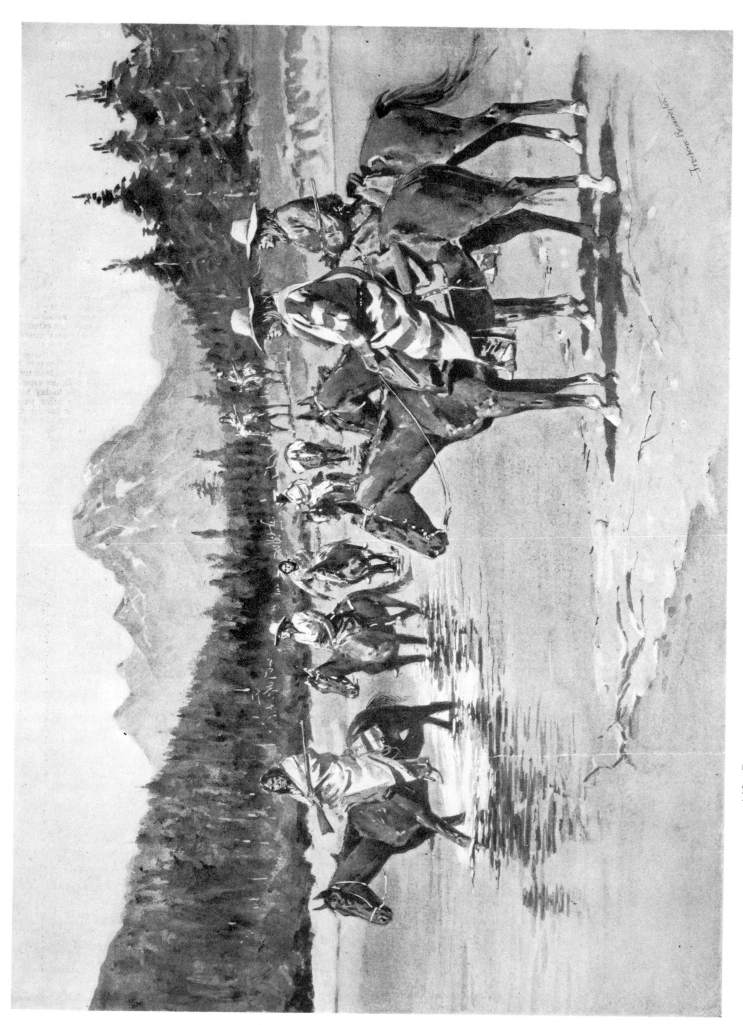

140 Recent Uprising among the Bannock Indians—A Hunting Party Fording the Snake River
Southwest of the Three Tetons (Mountains)